TEXAS

Portrait of a State

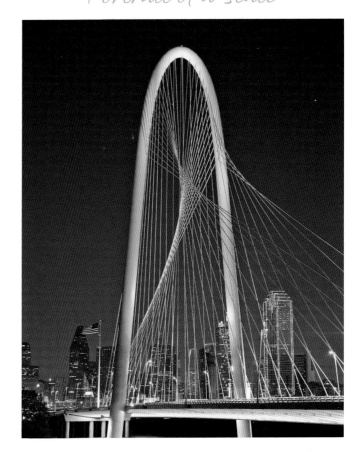

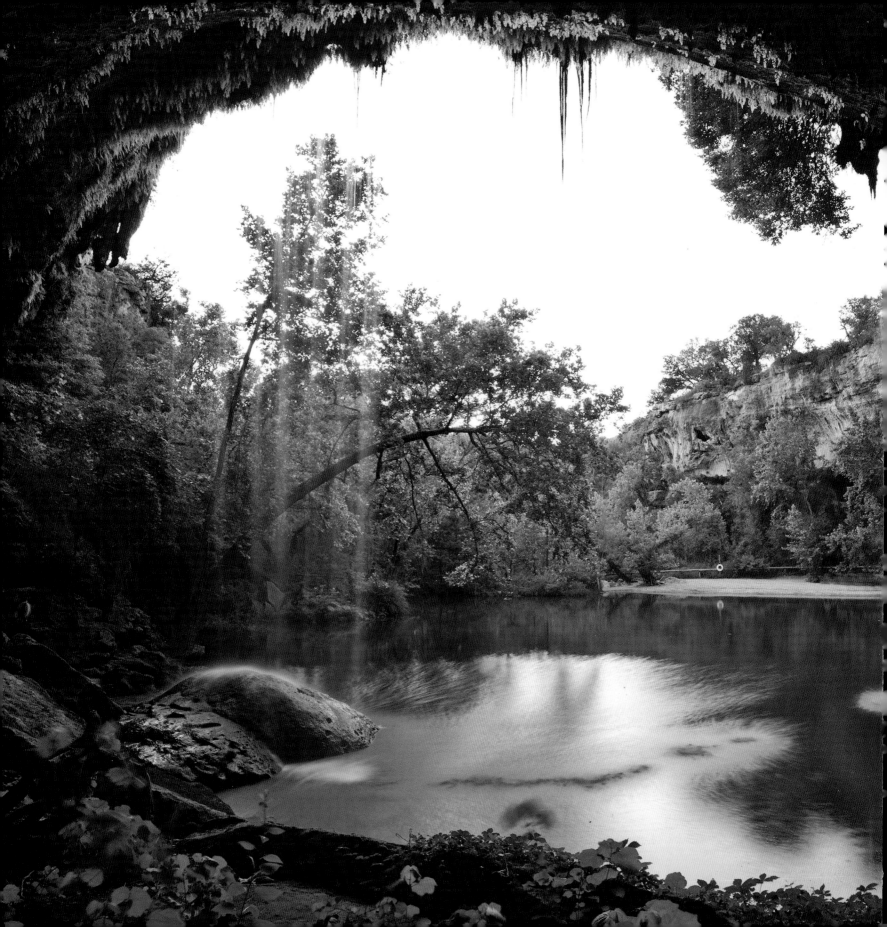

TEXAS
Portrait of a State

LAURENCE PARENT

GRAPHIC ARTS
BOOKS®

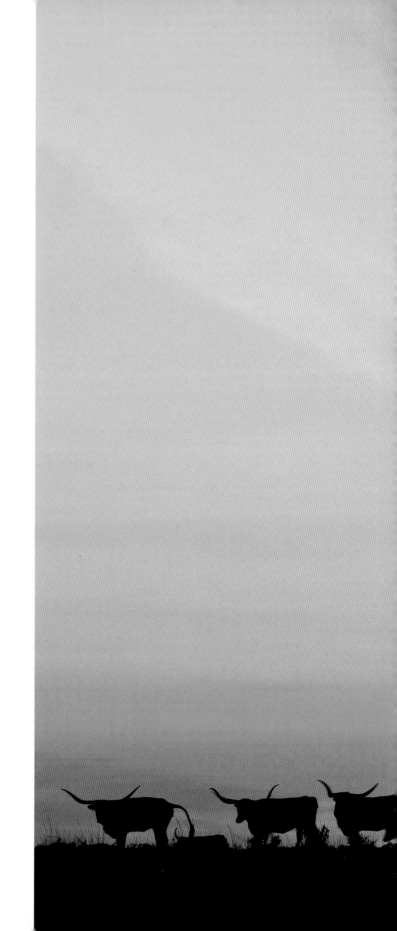

Library of Congress Control Number: 2013938226
International Standard Book Number: 978-0-88240-915-3

Book design: Jean Andrews

Captions and book compilation © MMXIII by
Graphic Arts Books, an imprint of Graphic Arts Books®
P.O. Box 56118
Portland, OR 97238-6118
(503) 254-5591
www.graphicartsbooks.com

Printed in China

◄◄ Designed by Santiago Calatrava, the Margaret Hunt Hill Bridge crosses the Trinity River in Dallas. A forty-story center-support arch tops off the curved center span.
◄ Situated in Travis County in the Hill Country, Hamilton Pool was officially designated a preserve in 1990. The pool was created when the roof of a cavern collapsed thousands of years ago. A fifty-foot waterfall flows into the pool.
► A brilliant sunrise silhouettes longhorn cattle and live oaks in Blanco County in the Hill Country.

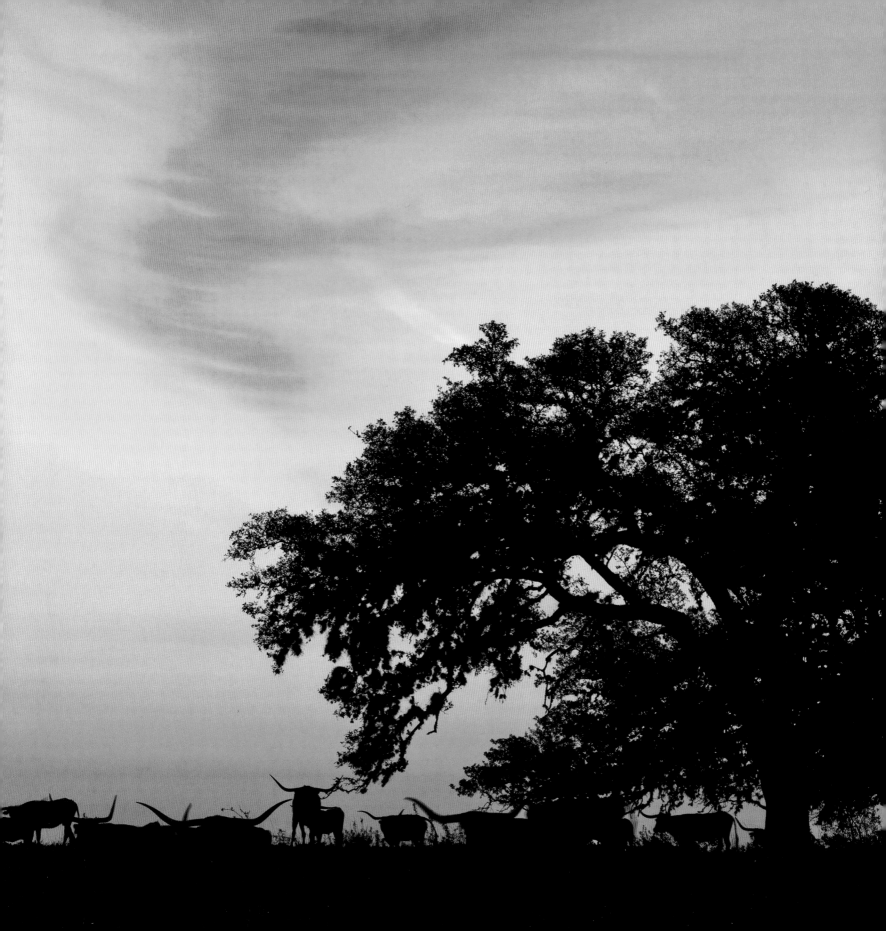

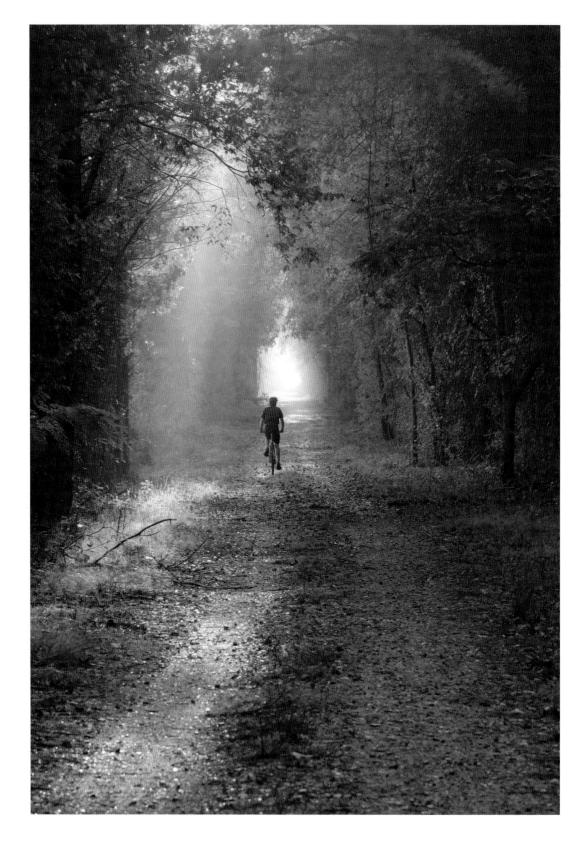

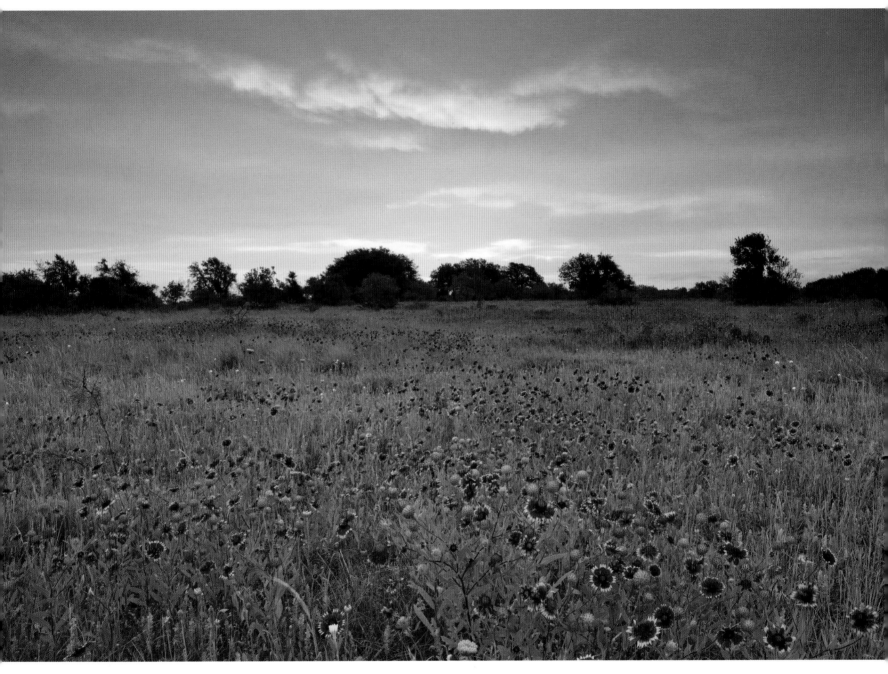

◄ The Northeast Texas Trail, following the path of an
old railroad, cuts through Bowie County in the New Boston
area. The 130-mile-long trail is now enjoyed by cyclists and hikers.
▲ Indian blanket *(Gaillardia pulchella)* carpets the area
near Pecan Creek in McCulloch County.

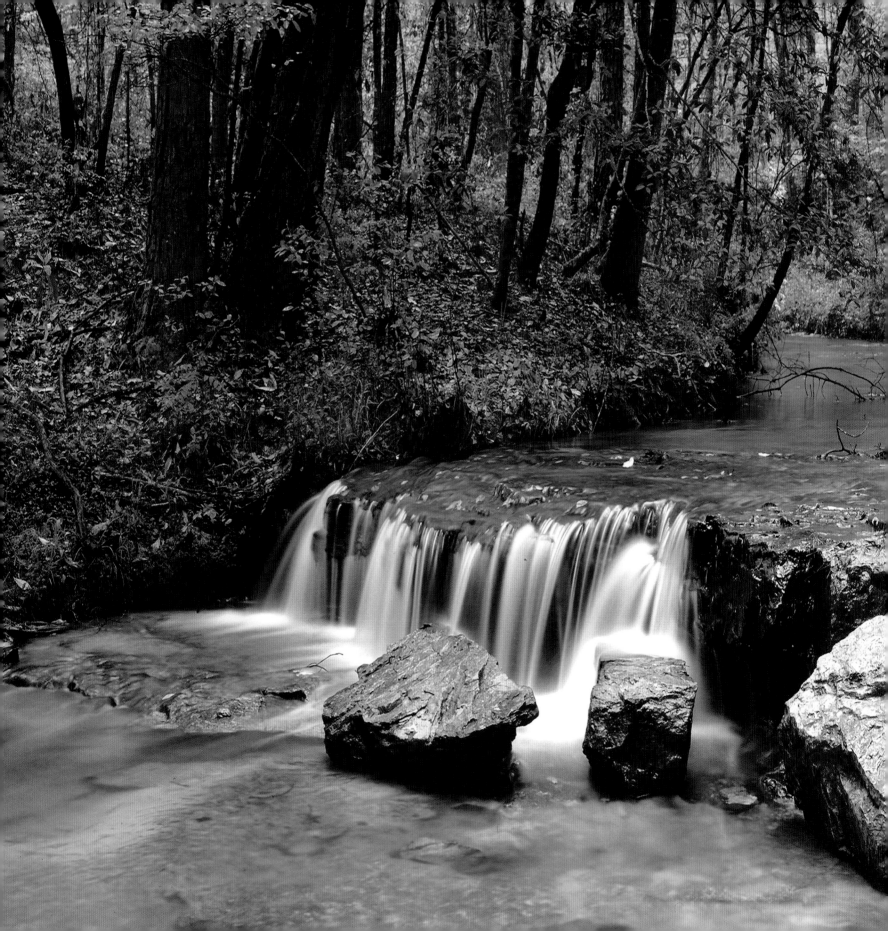

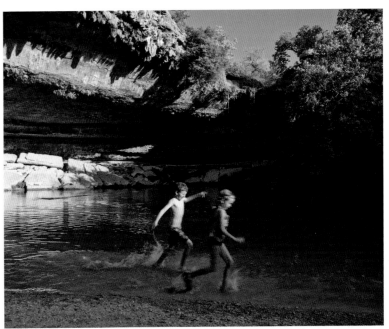

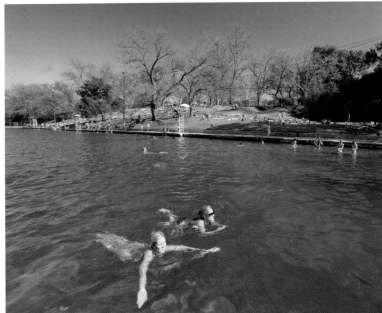

◄ Boykin Springs, in the Angelina National
Forest, offers camping, fishing, and pristine beauty.
▲▲ Hamilton Pool Preserve consists of 232 acres. Here,
Michelle and Jason Parent play in the pool's cool waters.
▲ The spring-fed sixty-eight-degree waters of Barton
Springs Pool in central Austin provide relief
from summer heat and humidity.

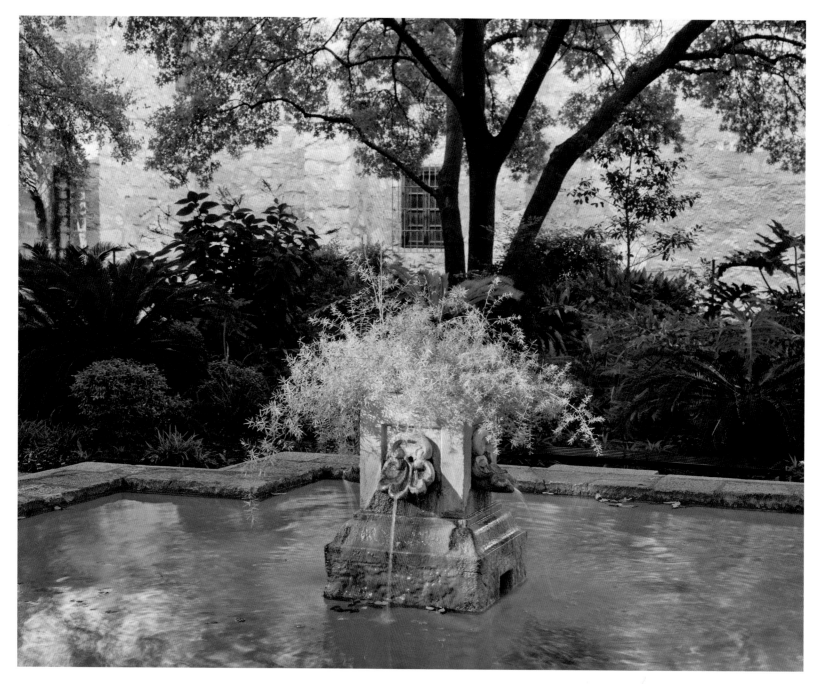

▲ The fountain in the garden area of the Alamo grounds was added after
the Battle of the Alamo in 1836. Only the chapel of the original mission still exists.
► Construction began in 1724 on San Antonio de Valero Mission, known today as the Alamo,
whose primary purpose was to convert the Indians to Christianity and educate them.
►► San Geronimo Creek rises six miles north of the town of San Geronimo and
runs southwest for twenty miles to its confluence with the Medina River.

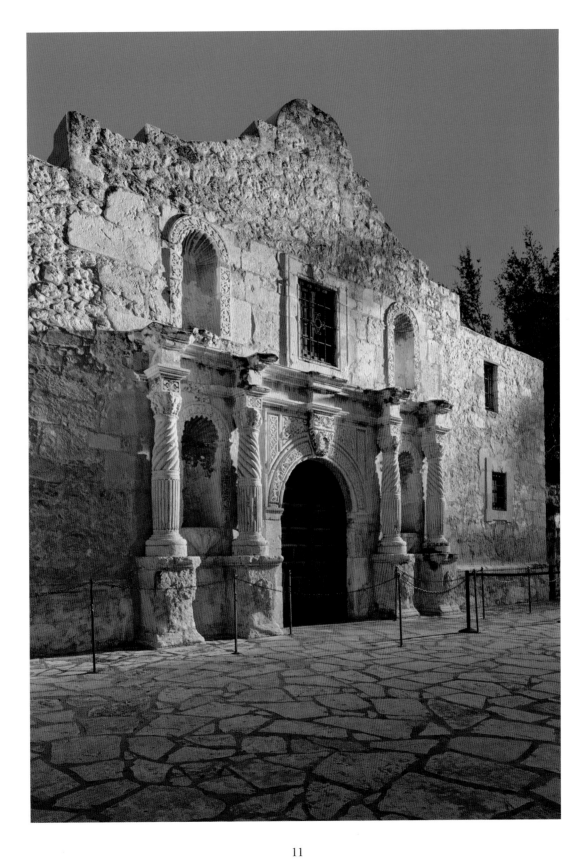

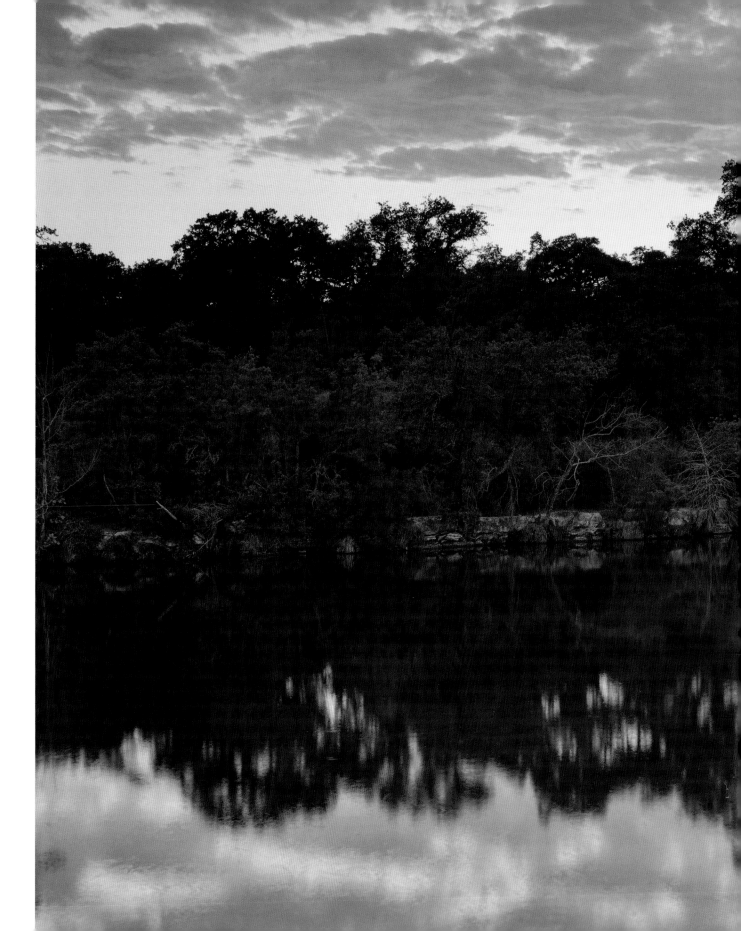

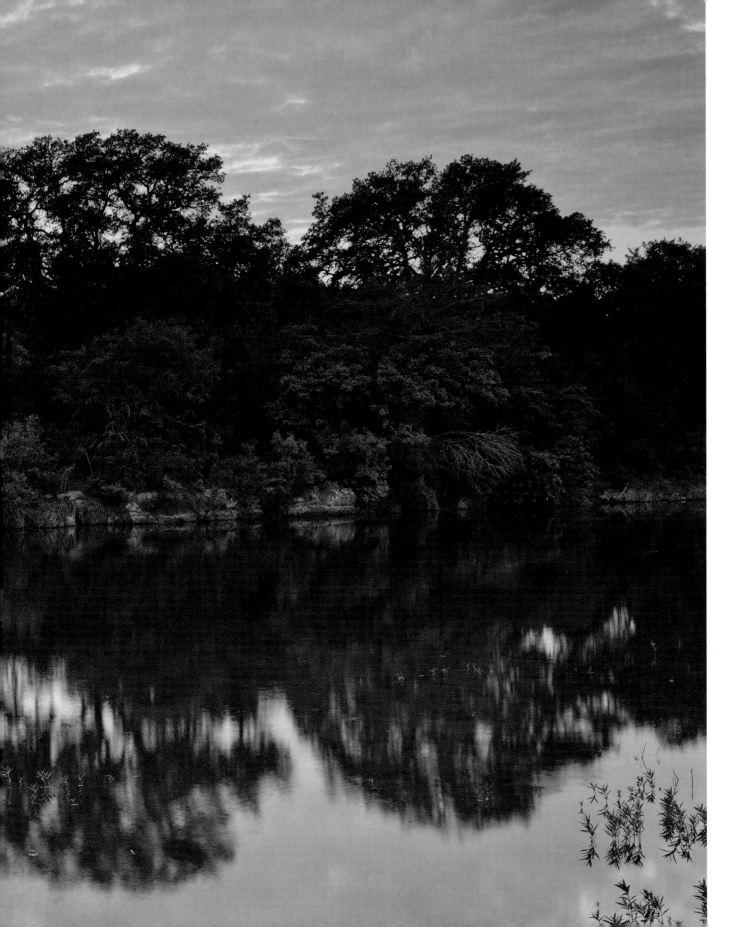

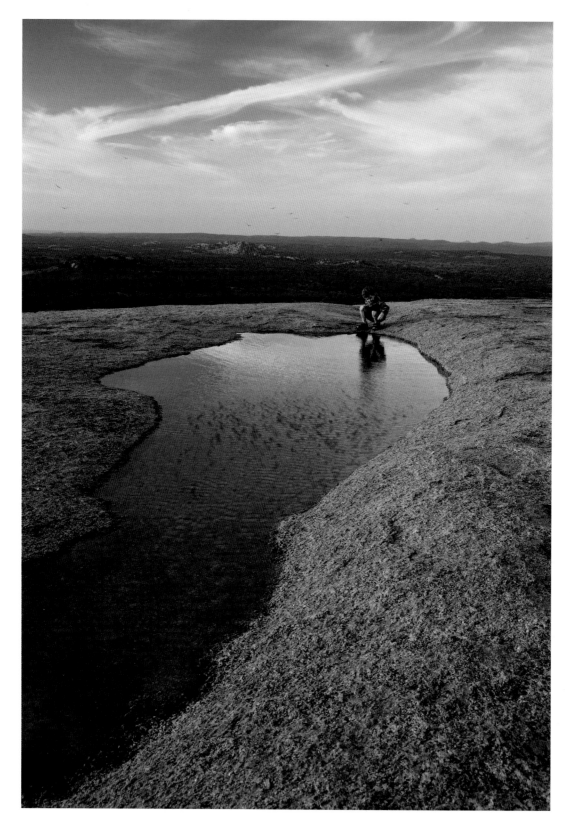

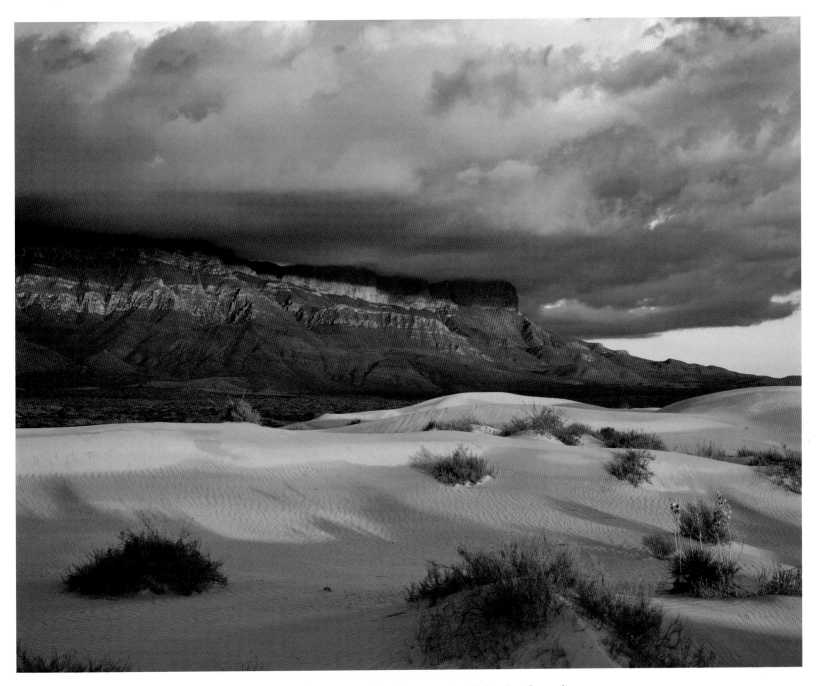

◄ Jason Parent squats beside a vernal pool that has formed
on the main granite dome at Enchanted Rock State Natural Area.
▲ Gypsum sand dunes mark the west side of Guadalupe Mountains National
Park. The Guadalupes have seen a varied history: conflicts between
Mescalero Apaches and Buffalo Soldiers, the passing of the
Butterfield Overland Mail, the coming of ranchers and
settlers, and finally, the making of a national park.

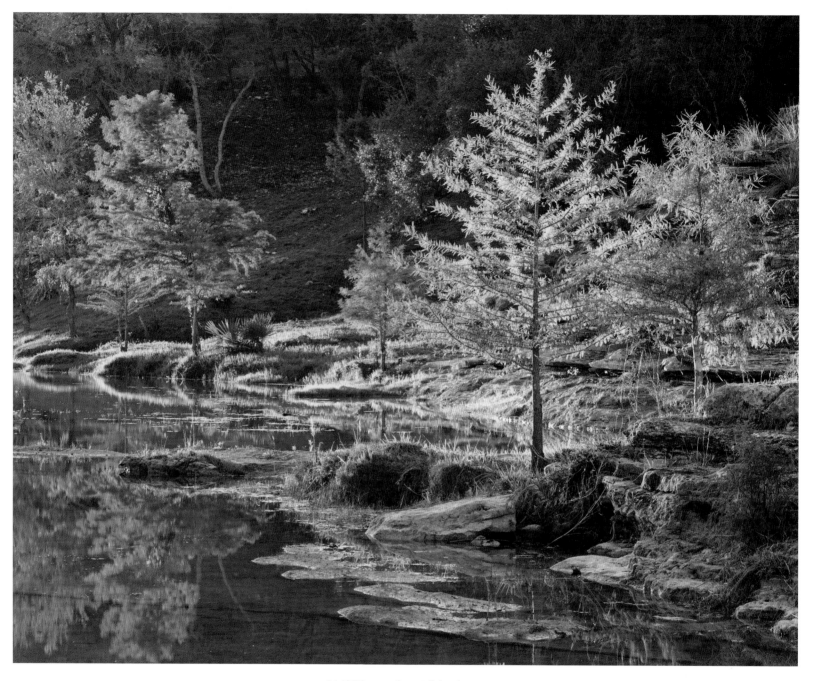

▲ In 1721, members of the Aguayo
expedition named the Blanco River for the
white limestone along the banks and in the streambed.
▶ Cadillac Ranch, in Amarillo, was created as an artistic work
in 1974 by Chip Lord, Hudson Marquez, and Doug
Michels, under the patronage of Stanley Marsh 3.

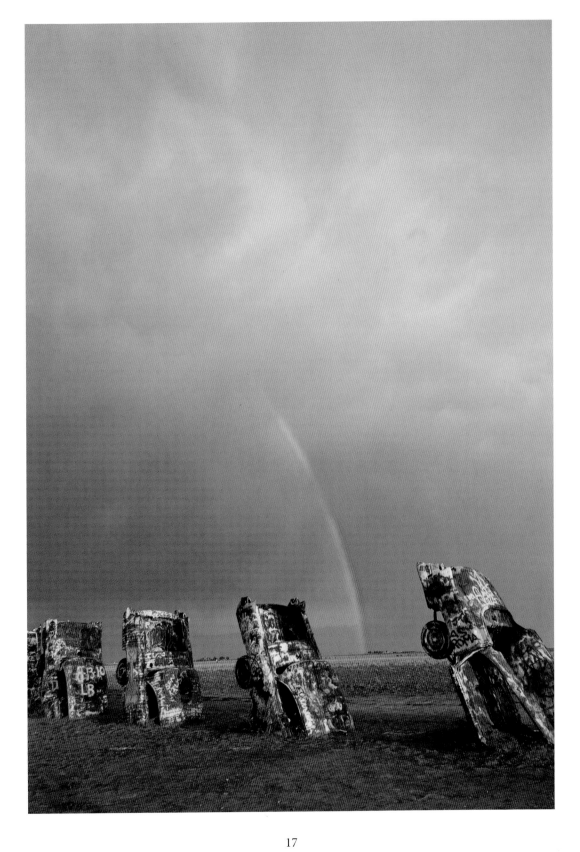

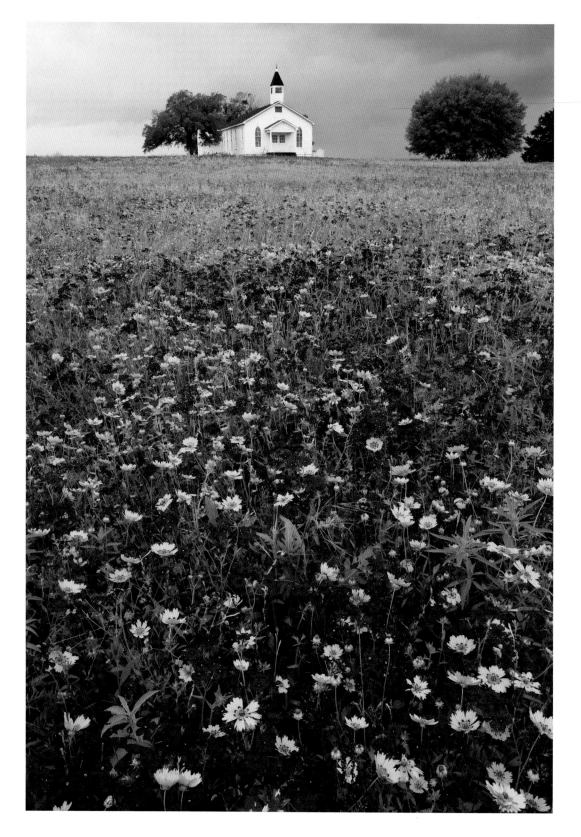

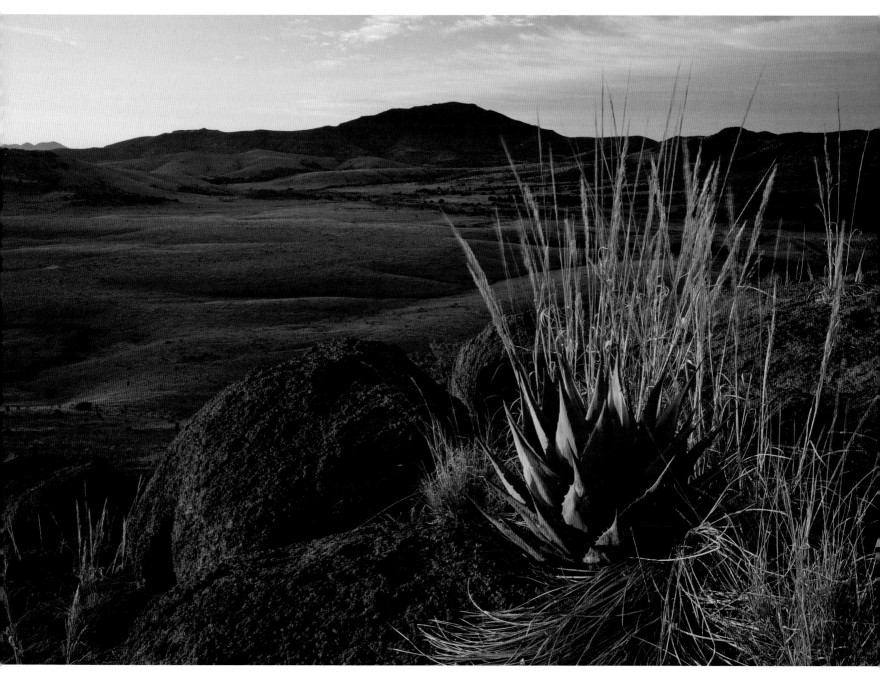

◄ Wildflowers—phlox *(Phlox drummondii)*, coreopsis *(Coreopsis sp.)*,
Texas paintbrush *(Castilleja indivisa)*—surround the interdenominational
Cheapside Community Church in Gonzales County. In the late 1800s, the church
was used by both Presbyterians and Baptists. The Presbyterians won out.
▲ The Davis Mountains form a backdrop at first light for
an agave plant on a ranch below Blue Mountain.

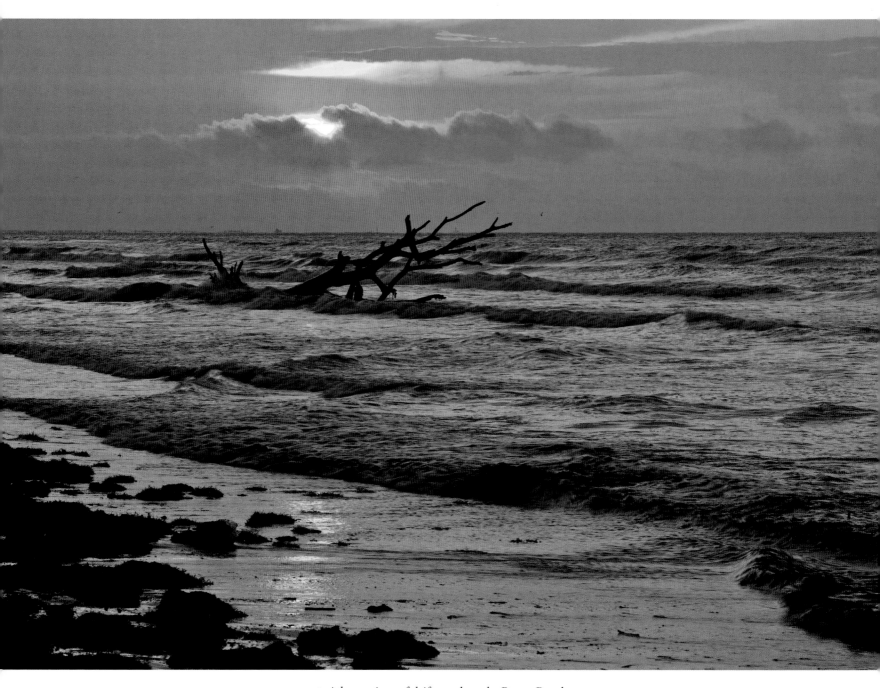

▲ A large piece of driftwood marks Bryan Beach,
in the Freeport area along the Gulf Coast. Although it is
sometimes a nuisance, driftwood returns nutrients to the environment
as it decomposes and serves useful purposes in providing
shelter and food for birds and fish.

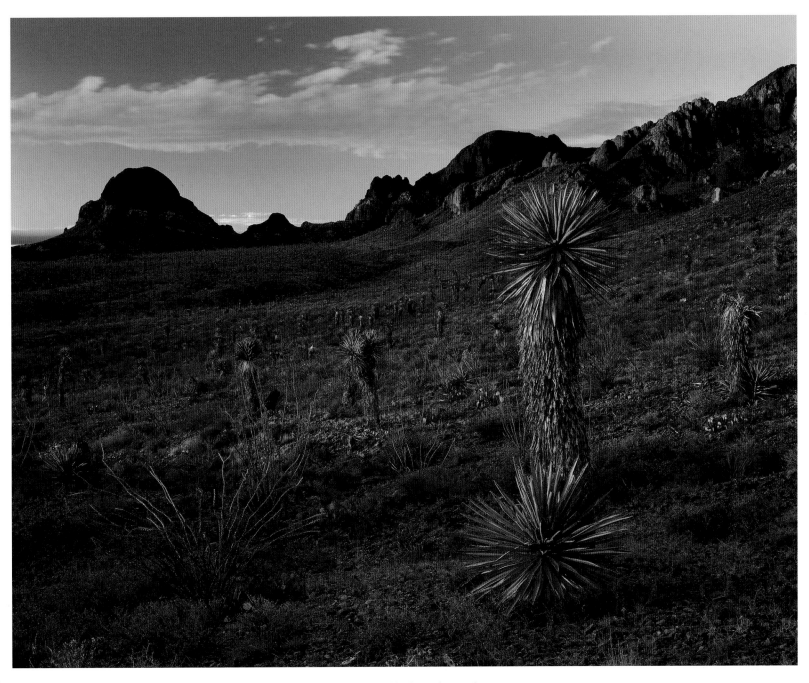

▲ Yucca plants dot a hillside in the Eagle Mountains.
There are some forty to fifty species of yucca. Both the fruits
and flowers of the yucca were consumed by Native Americans, and
the plant was also used for sewing and weaving material.

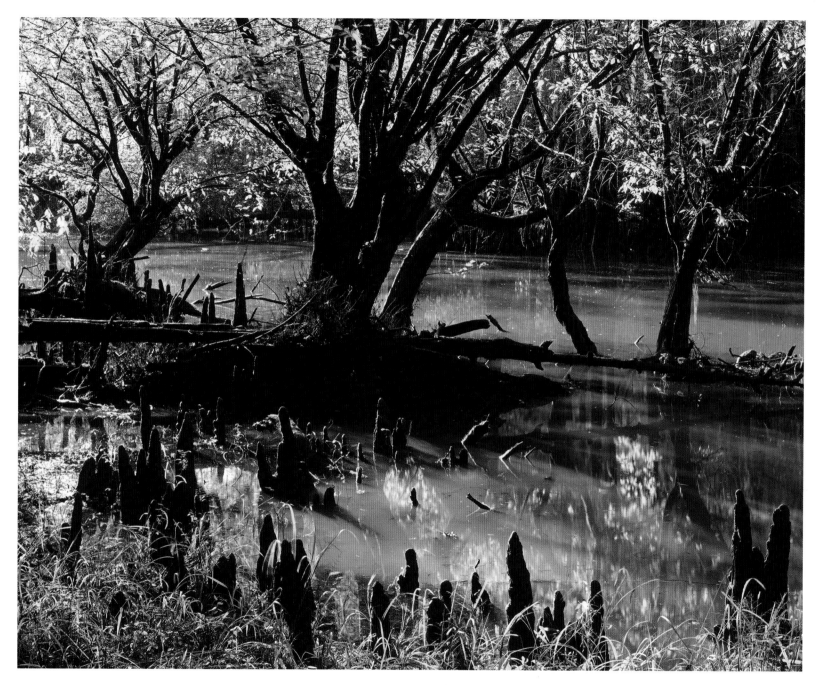

▲ Cypress knees dot a slough off the Neches River near Cypress Lake
in Angelina County. The knees are thought to provide stability to the tree.
▶ Spring Lake, source of the San Marcos River, is bordered by bald cypress.
▶▶ Encompassing 1.75 acres, the pool at Balmorhea State Park
is one of the world's largest spring-fed pools.

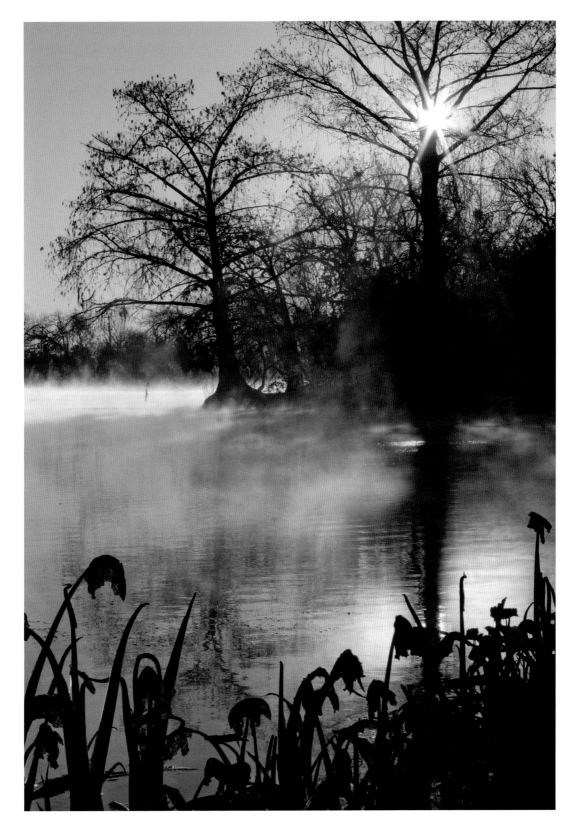

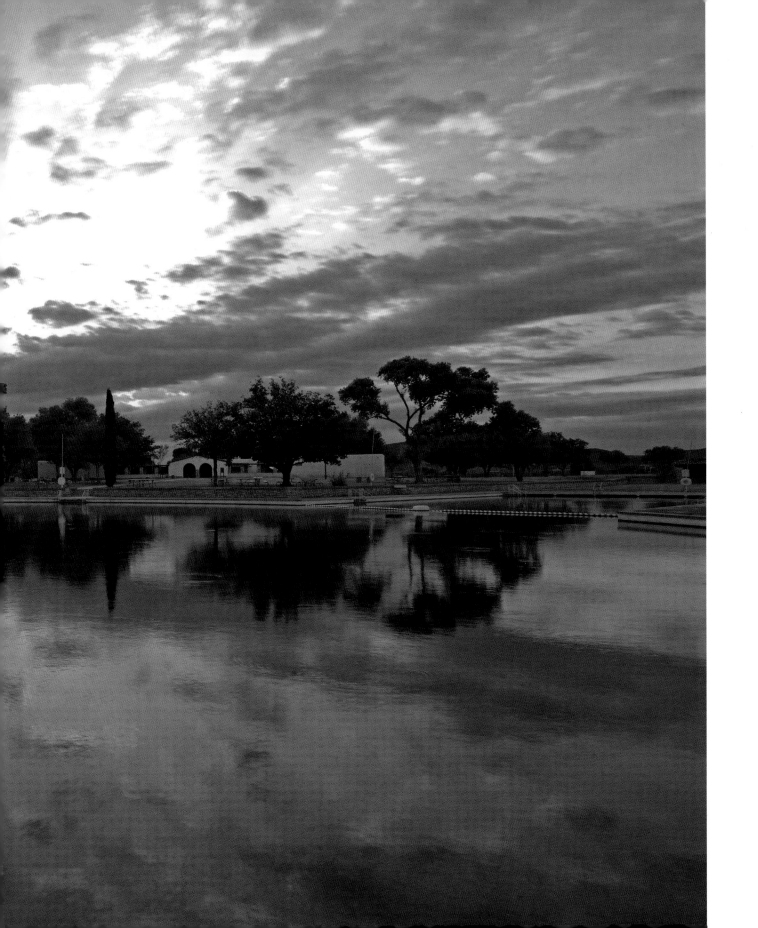

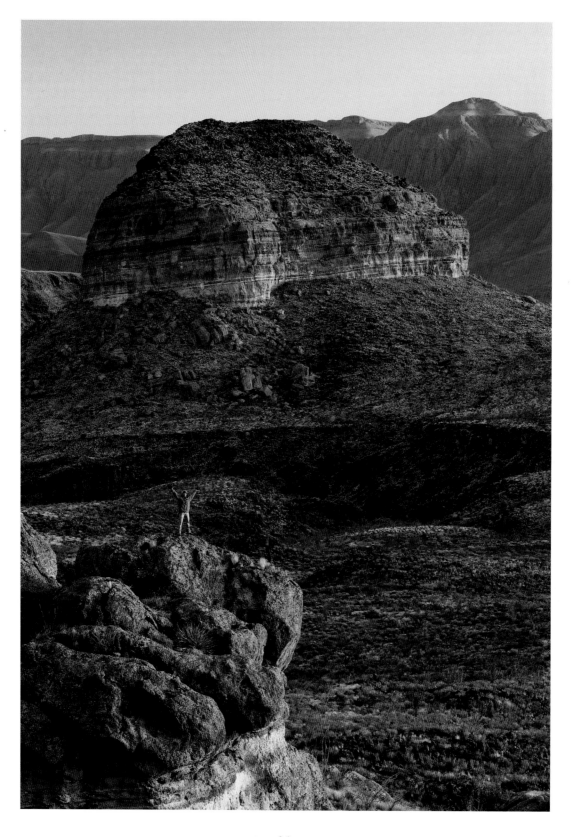

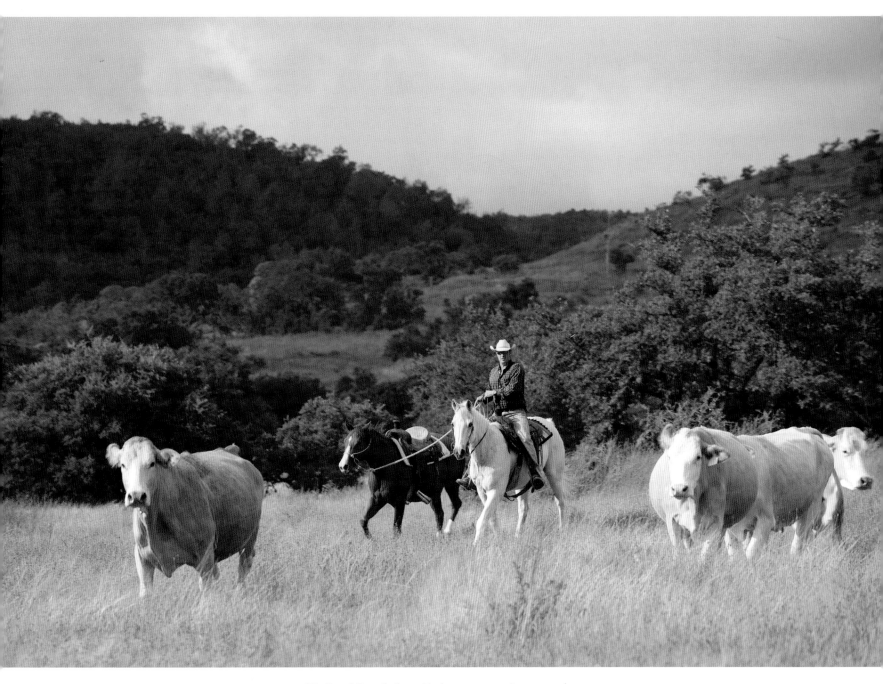

◄ Big Bend Ranch State Park, encompassing more than
300,000 acres, is the largest state park in Texas. Here, hiker Mary
Baxter waves from a high bluff on Guale Mesa below Sierra de la Guitarra.
▲ Cowboy Scott Grote works on the Selah Bamberger Ranch Preserve in Blanco County.
►► A road heads toward the Beach Mountains beneath a brilliant sunset.

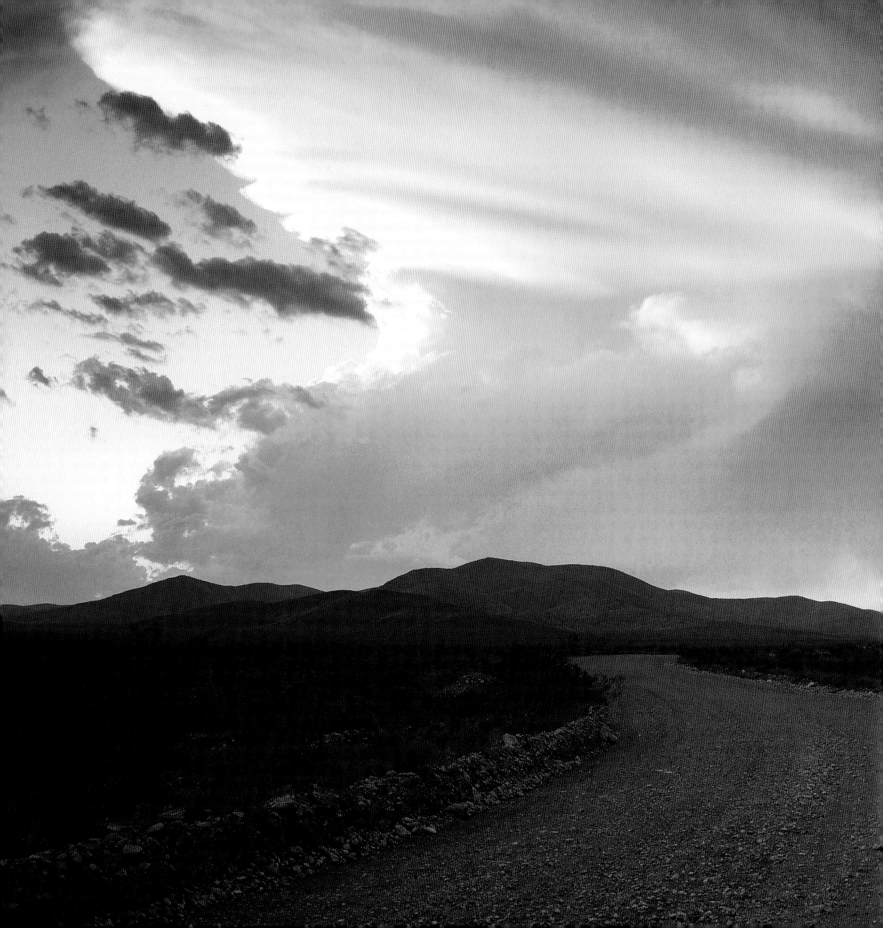

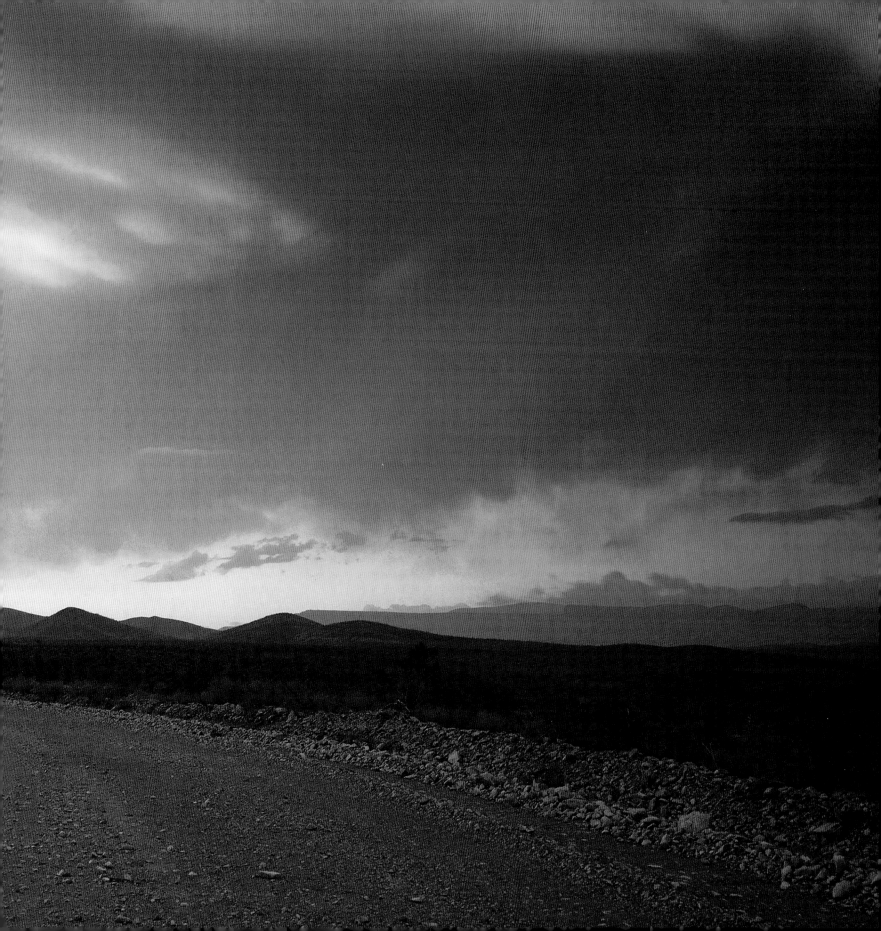

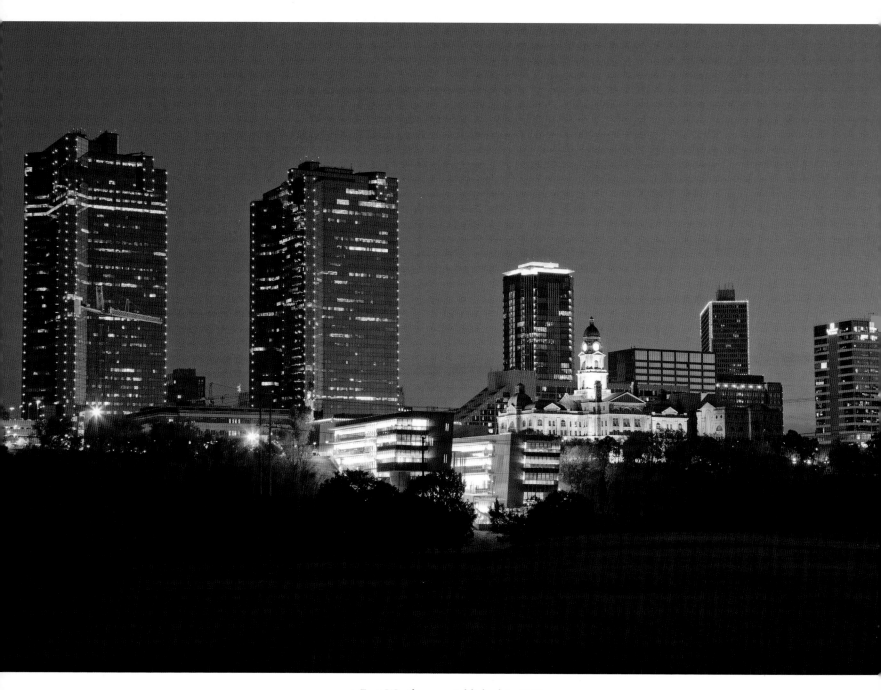

▲ Fort Worth was established in 1849
as an army outpost. It has grown since then to
a population of 741,206 as of the 2010 census. It is
the second-largest city in the Dallas–Fort Worth
metroplex, encompassing nearly 350 square
miles and is the Tarrant County seat.

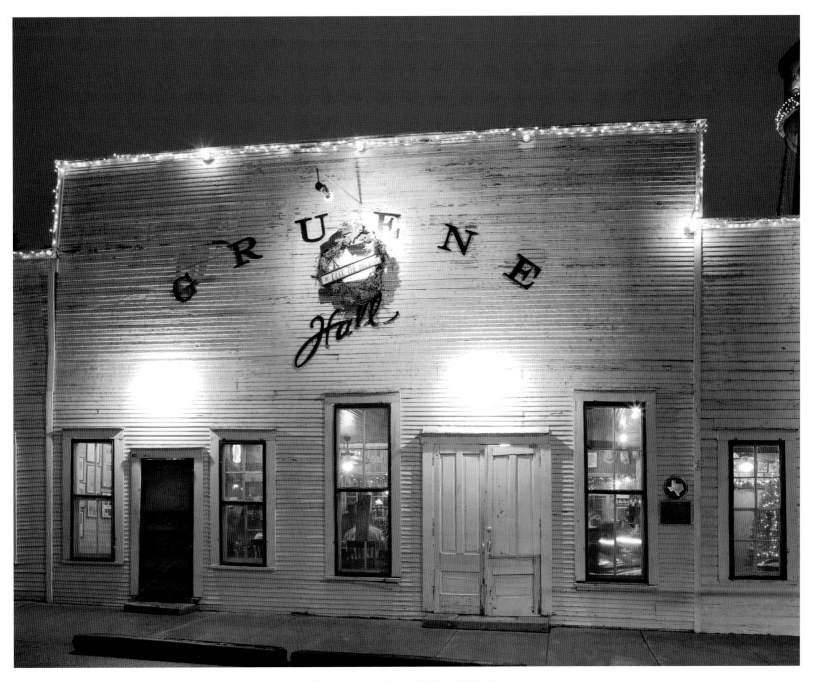

▲ Built in 1878 by Henry (Heinrich) D. Gruene,
Gruene Hall is the oldest continuously operated dance
and music hall in Texas. It is situated in the historic town
of Gruene, Texas, now a part of New Braunfels.

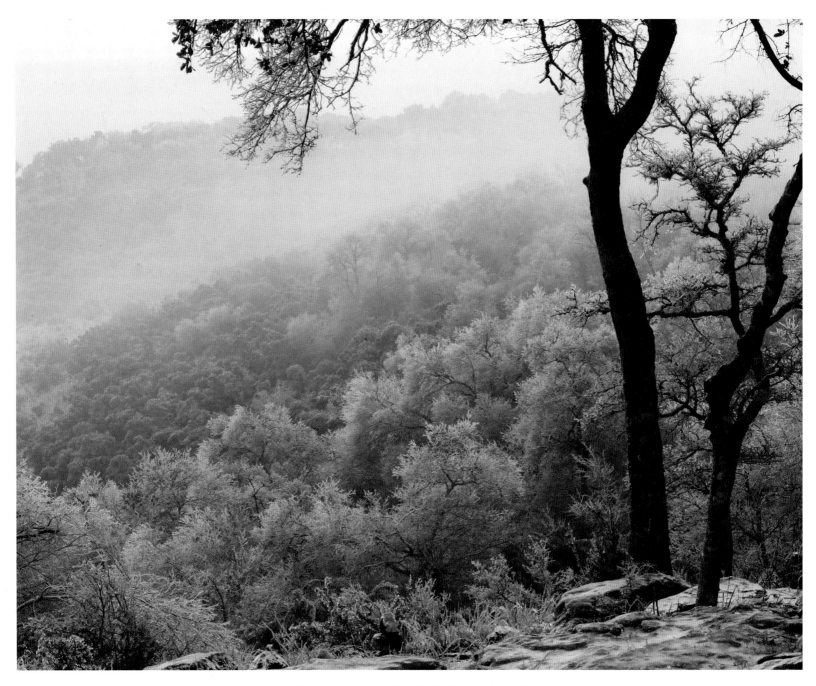

▲ The road along the Devil's Backbone above the
Blanco River Valley, near Wimberley in the Hill Country, offers
sprawling vistas. Here, one of those views is of ice blanketing everything.
▶ In winter, Hamilton Pool in Travis County boasts new and
different decorations—icicles hanging above the pool.

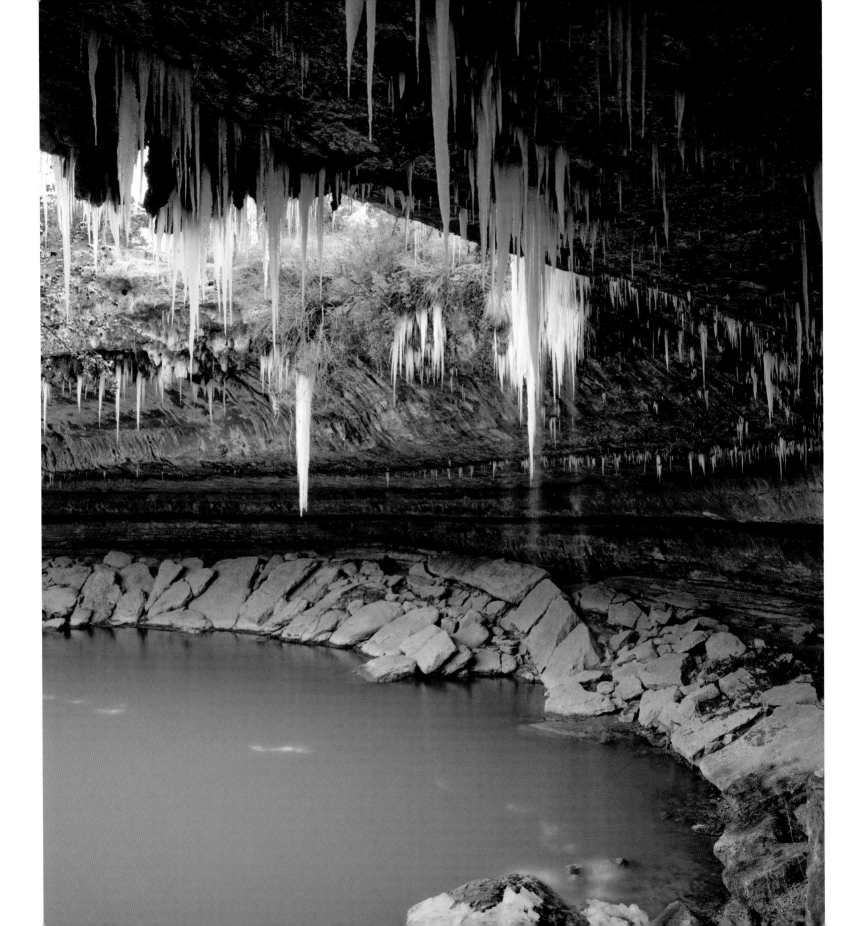

◄ The Beach Mountains, reaching as high as 5,827 feet, are an uplifted block
along the edge of a broad salt-flat valley. The mountains are named for J. H. Beach,
who came to Van Horn in 1886. Hackberry Creek runs through the sandstone slickrock.
▲ Haynes Ridge provides an expansive view of 15,314-acre Caprock Canyons State
Park. Bison were reintroduced to the area in 2011, and the park is now
home to some eighty animals, who again roam their native land.

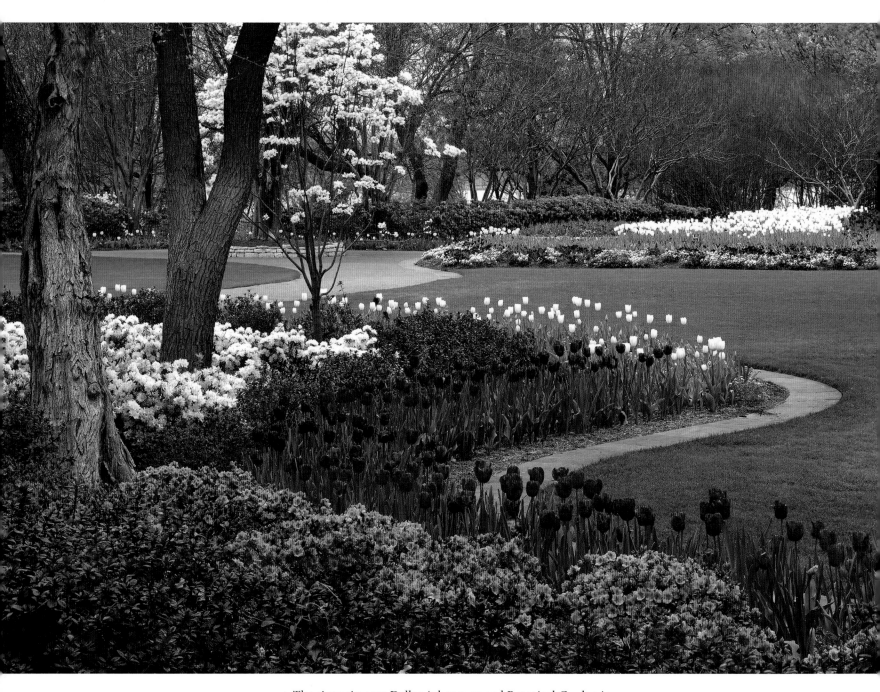

▲ The sixty-six-acre Dallas Arboretum and Botanical Garden is
actually a series of gardens. Shown here is a colorful garden of azaleas, tulips,
and dogwoods blooming in profusion. The gardens are the combined lands of the
original Rancho Encinal, built for geophysicist Everette Lee DeGolyer and his
wife, Nell, and the adjoining Alex and Roberta Coke Camp estate.

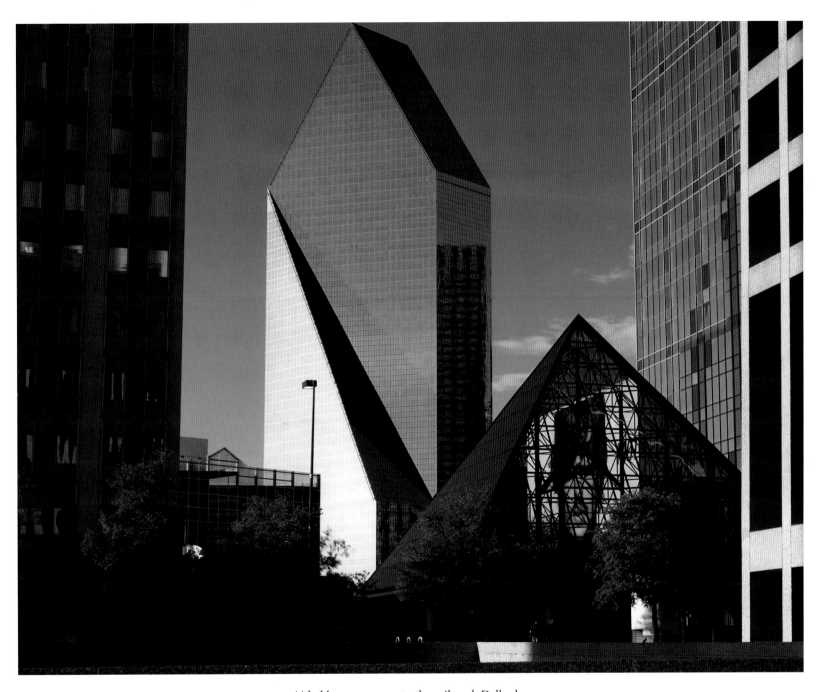

▲ Aided by easy access to the railroad, Dallas began
in 1841 and later became a hub for the oil and cotton
industries. Today, it boasts a population of more than a
million. The Dallas–Fort Worth metroplex is the
largest metropolitan area in the South.

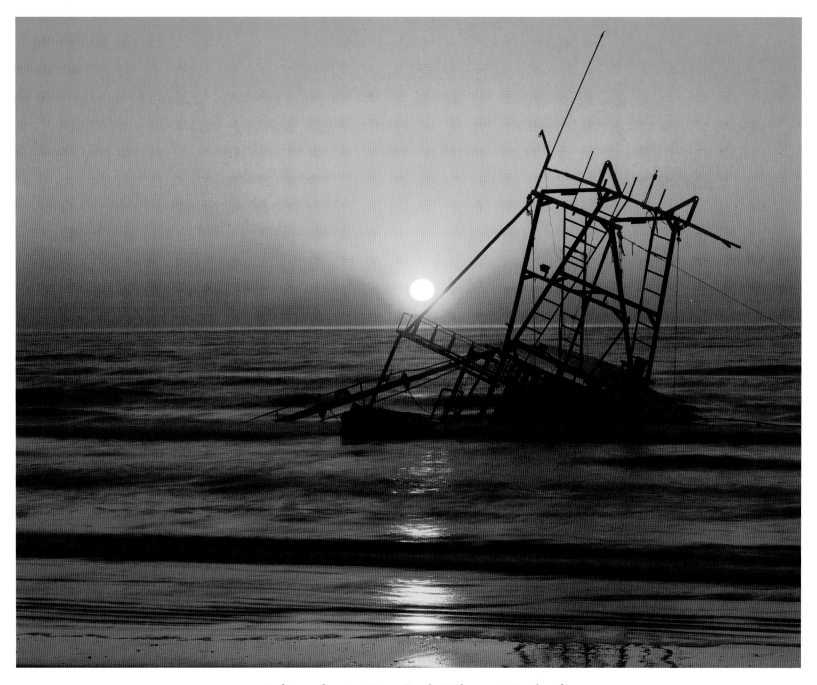

▲ A shipwreck rests at Bryan Beach. With some 367 miles of
coastline, the Texas Gulf Coast has been the graveyard for many
vessels, including the Civil War gunship USS *Westfield*.

► Kayakers Keri Thomas and Amie Hufton paddle in Dead Mans
Canyon, on the Pecos River arm of Amistad National Recreation Area.

►► Listed on the National Register of Historic Places, Krause Springs was probably
used by Native Americans for centuries before European settlement.

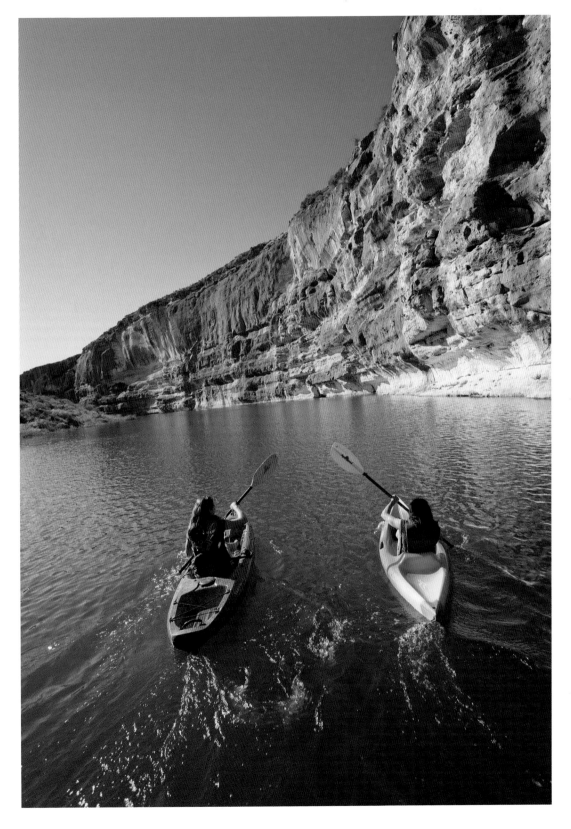

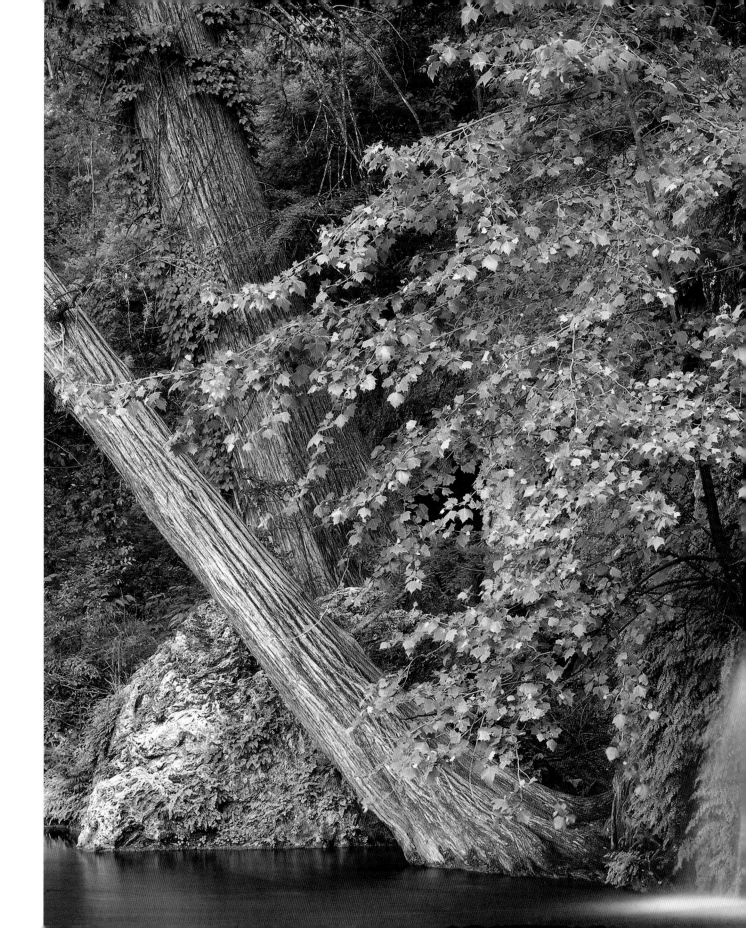

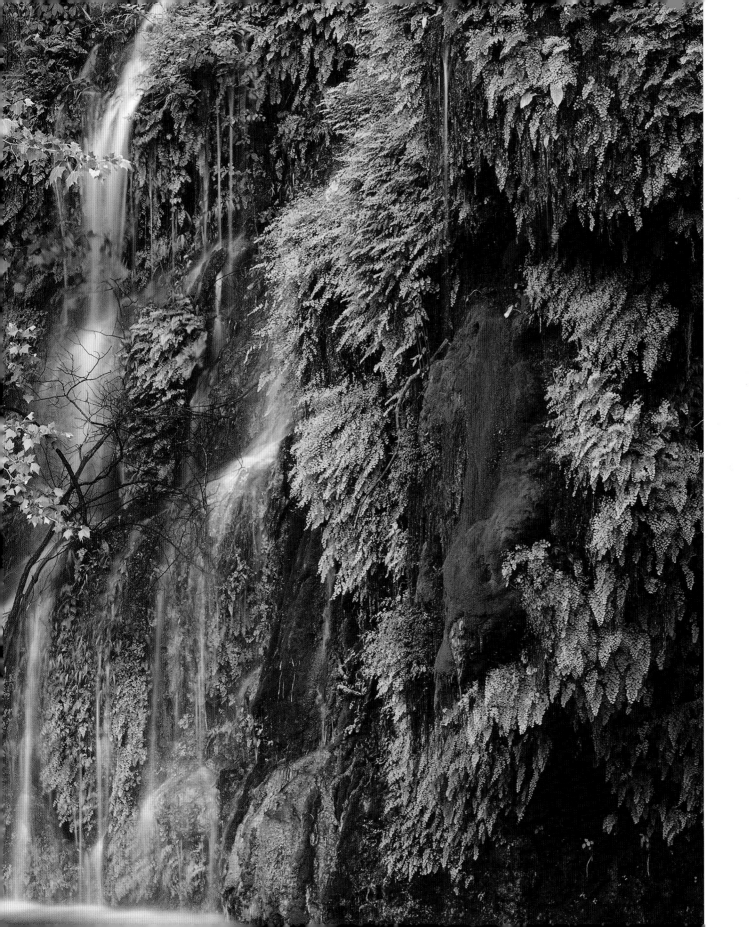

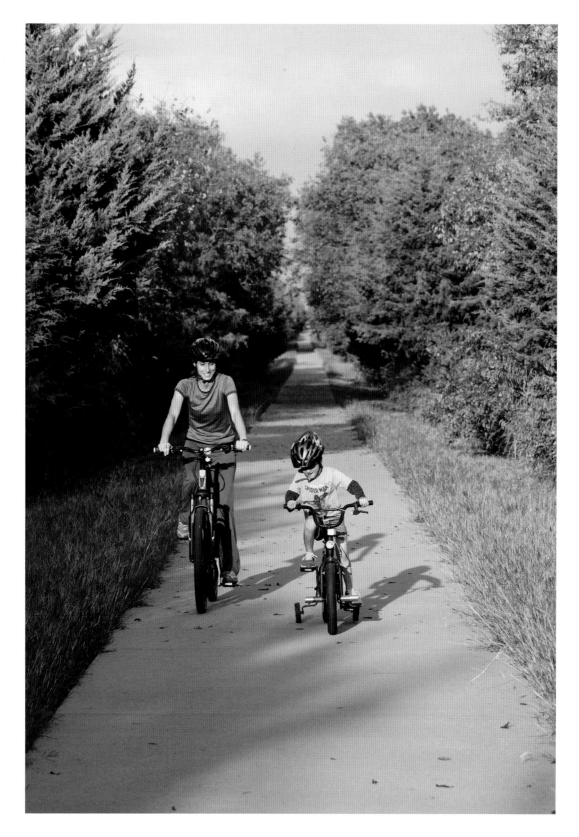

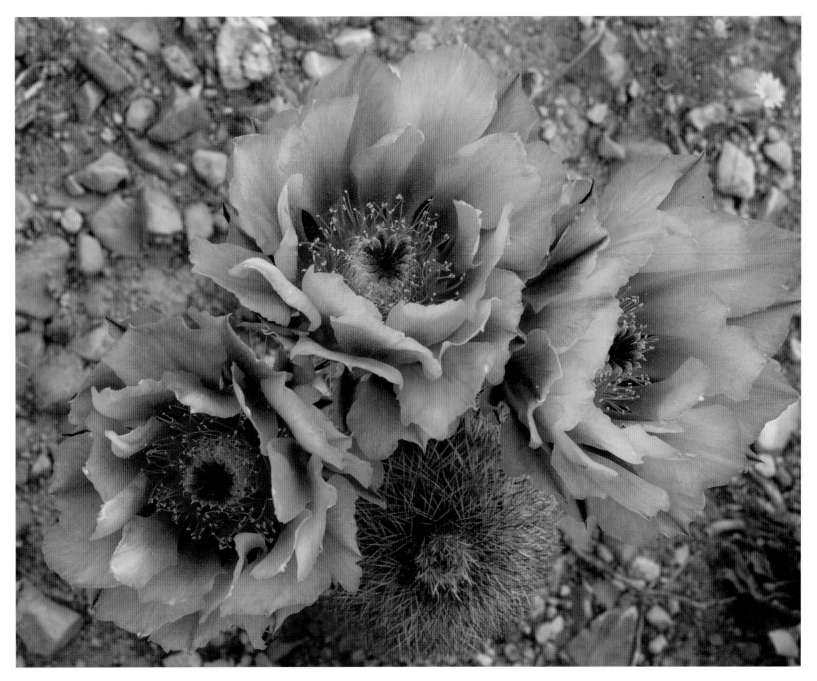

◄ The Northeast Texas Trail (NETT) stretches 130 miles
from Farmersville to New Boston. Cyclists Emily Dillard and her
son Carson are enjoying the Chaparral Rail Trail section near Farmersville.
▲ Rainbow cactus *(Echinocereus dasyacanthus)* is native to Texas, New Mexico,
Arizona, and Sonora, Mexico. This example is in Big Bend National Park.
►► Salt Flat in Hudspeth County lies at about 3,600 feet, almost a vertical
mile below the Guadalupe Mountains that rise to the east.

43

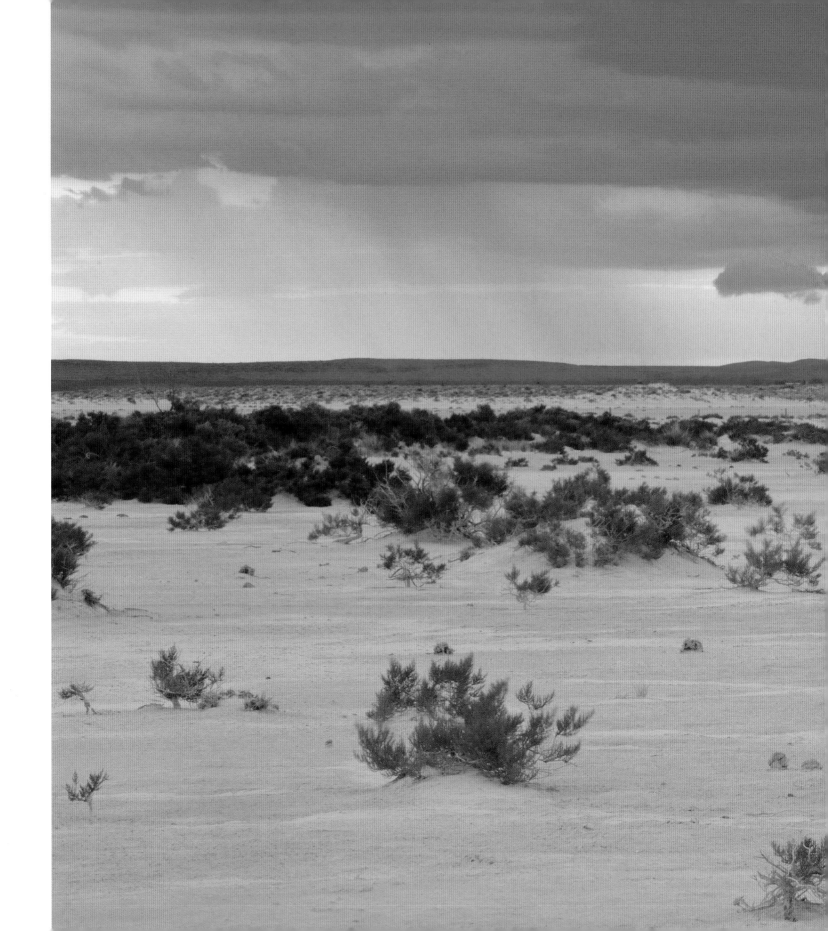

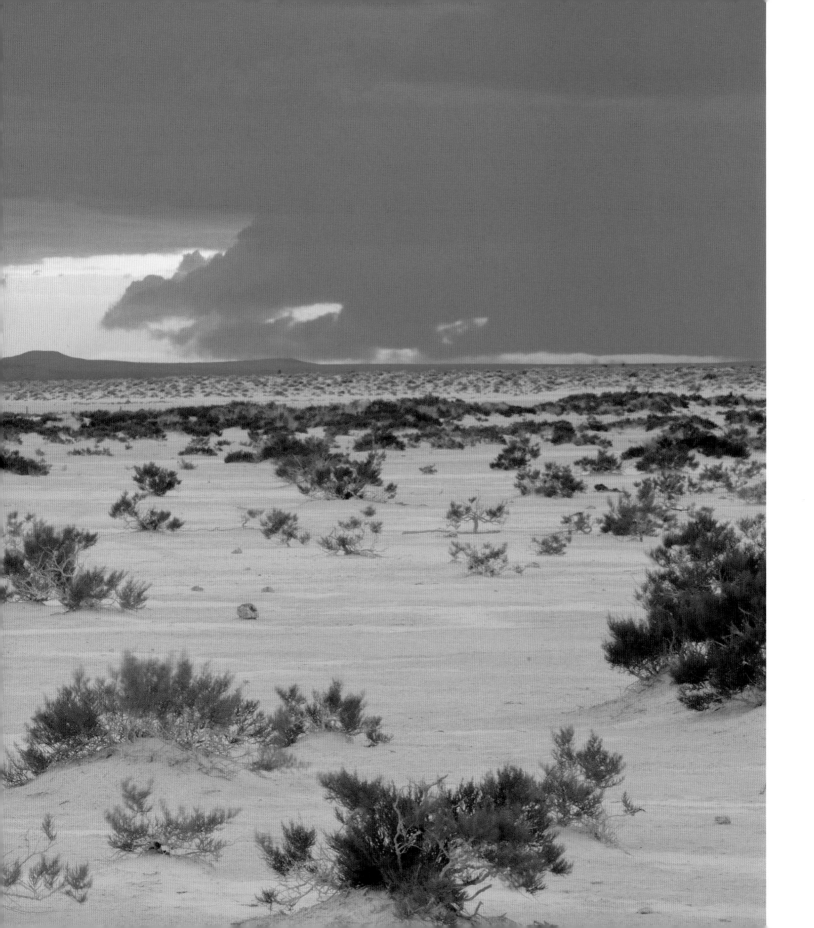

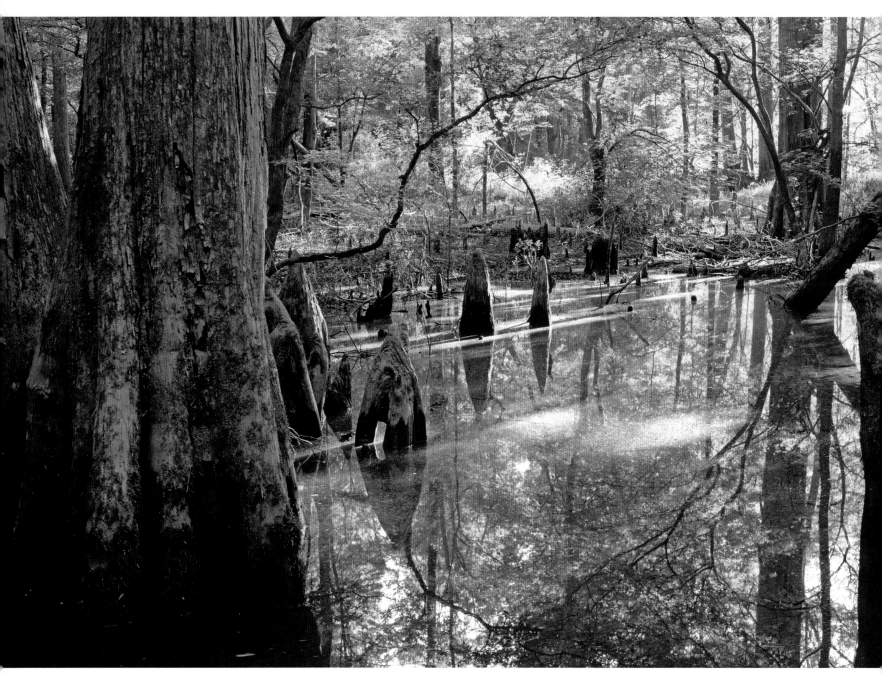

▲ Established in 1974 to protect what has been described
as one of the most biodiverse areas in the world, Big Thicket National
Preserve includes a Village Creek cypress slough, seen here.
▶ Situated in the Chinati Mountains, Cibolo Creek Ranch encompasses 30,000
acres. Three restored 1850s forts offer luxurious lodging and dining to guests.

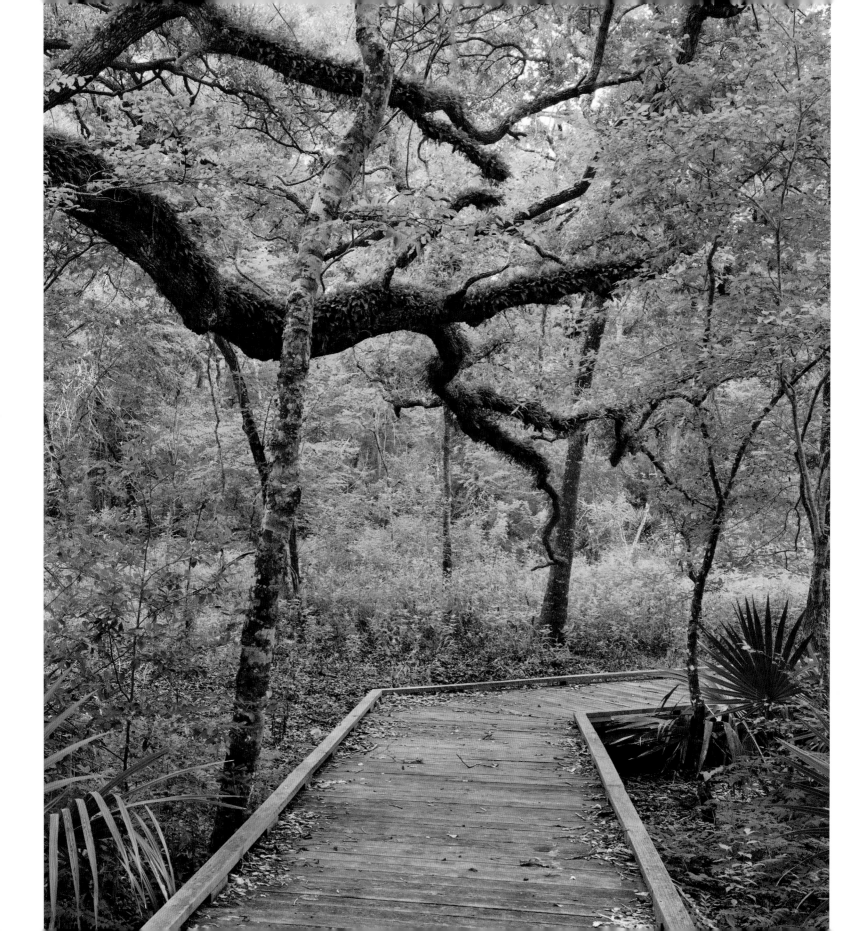

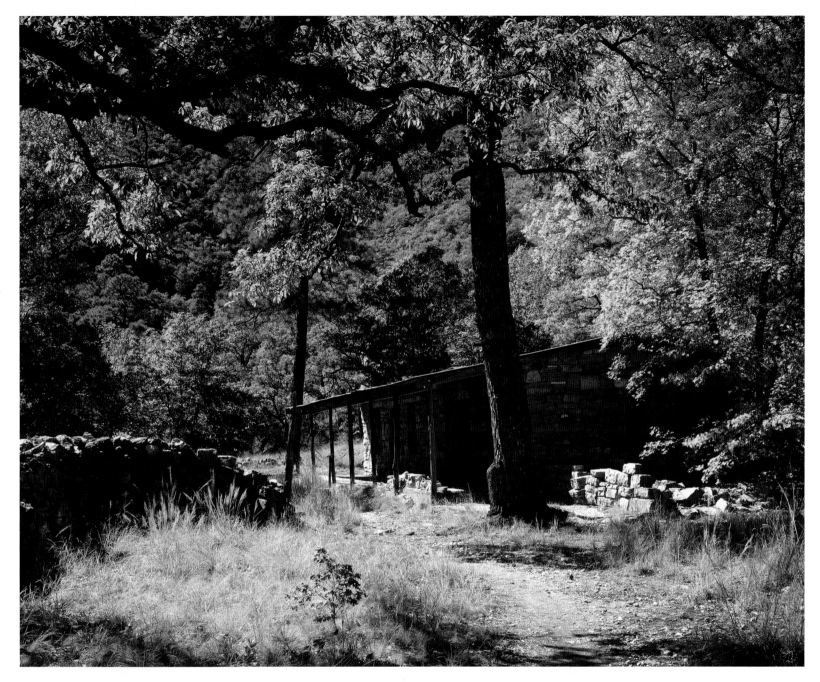

◄ A wooden boardwalk through the San Bernard National Wildlife
Refuge leads to the largest live oak *(Quercus virginiana)* in Texas. "Big Tree"
has a circumference of thirty-two feet and a height of sixty-seven feet.
▲ The historic Hunter Line Cabin nestles in McKittrick Canyon
in Guadalupe Mountains National Park.

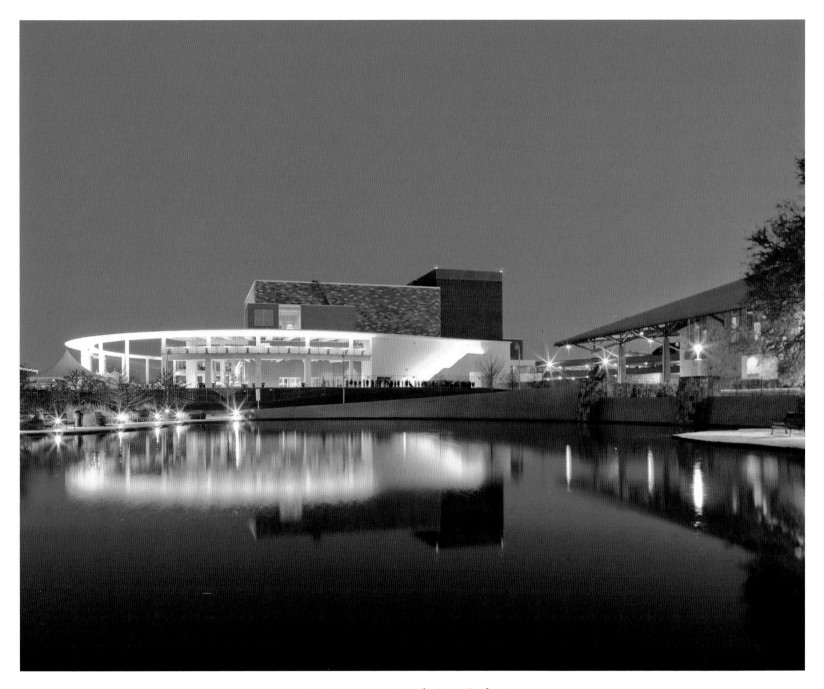

▲ During construction, the Long Performing
Arts Center recycled 95 percent of the 44 million
pounds of construction material from the old Palmer Auditorium.
▶ The pond at the Palmer Events Center reflects the downtown Austin skyline.
▶▶ Sotol grows below 7,192-foot North Franklin Peak in Franklin
Mountains State Park, one of the largest urban parks in
the country lying entirely within city limits.

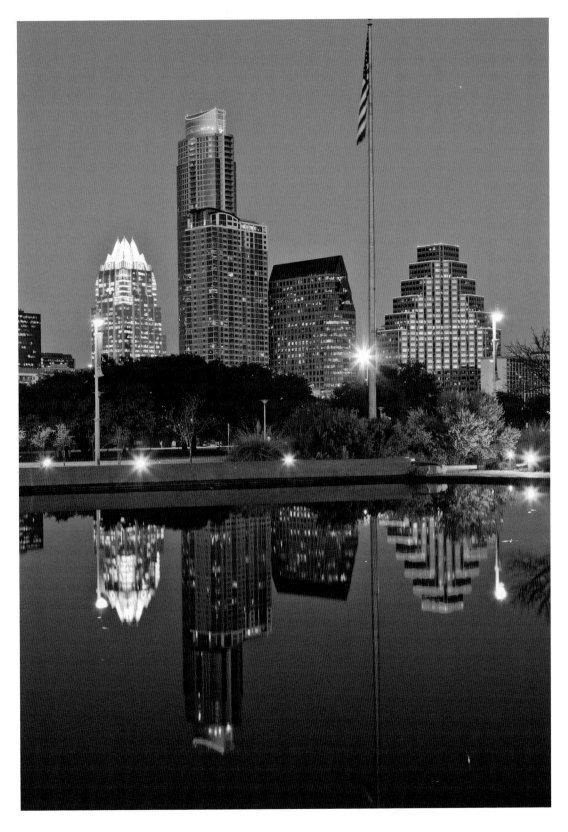

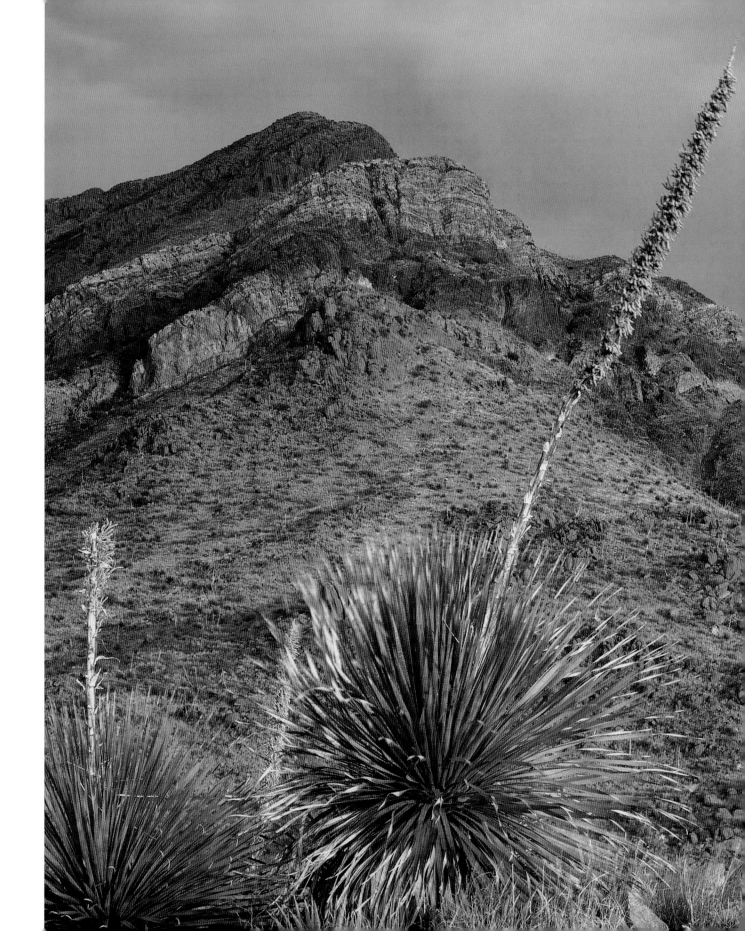

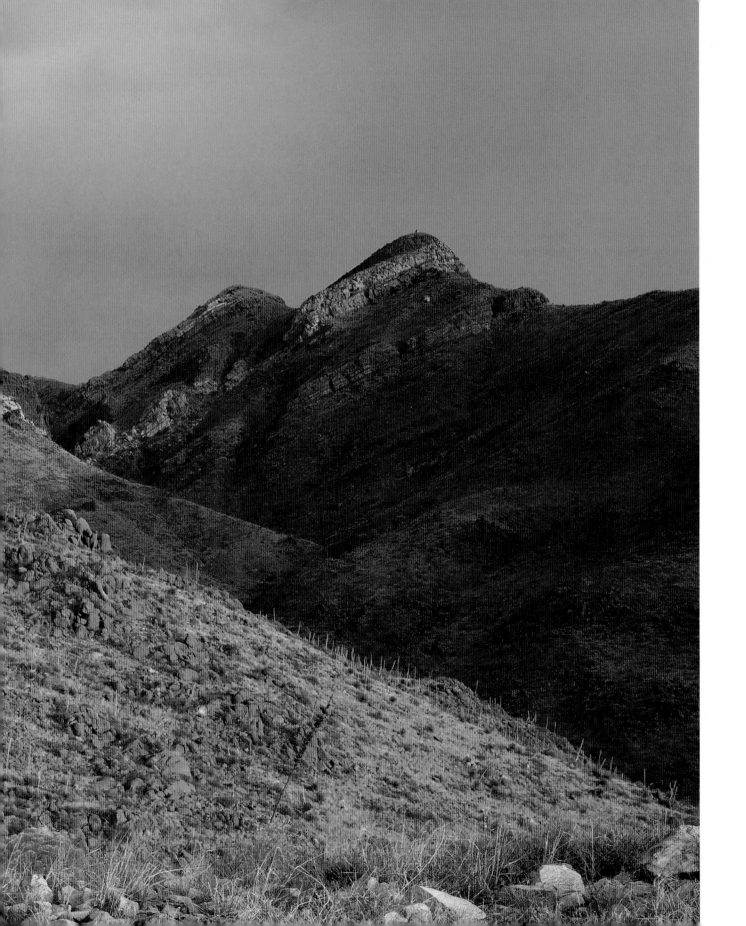

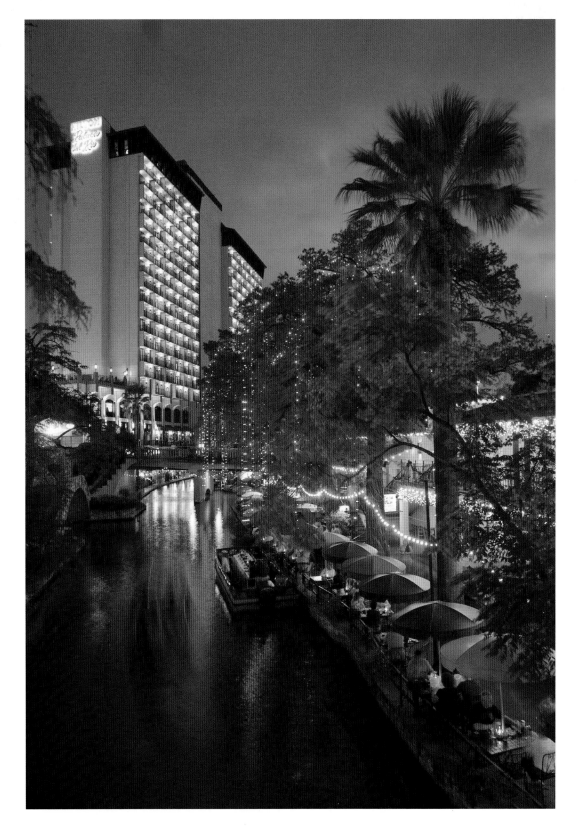

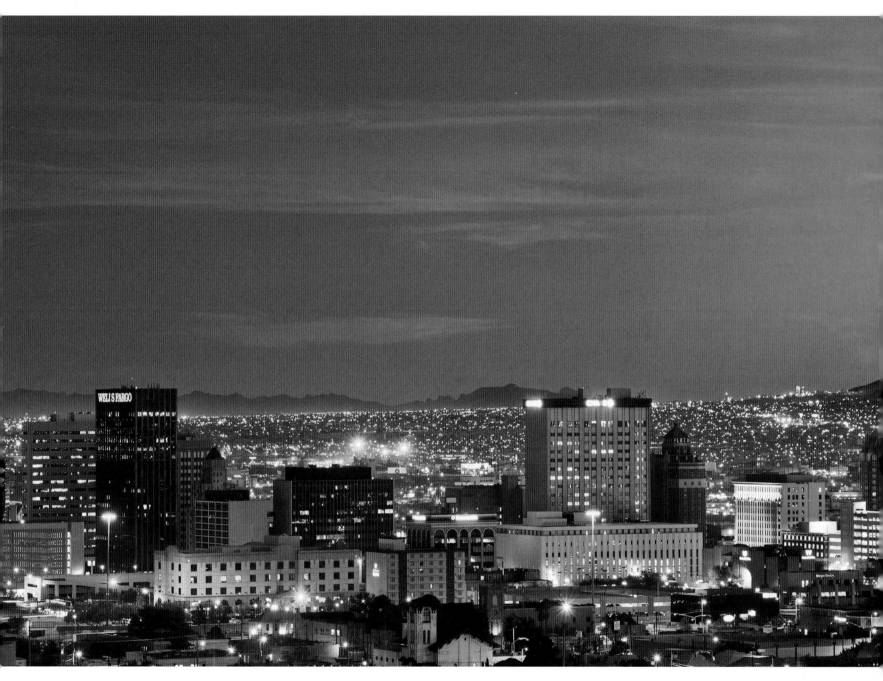

◄ The San Antonio River Walk, also known as Paseo del
Río, is a network of walkways along the San Antonio River.
It is situated one story lower than the streets of the city.
▲ The lights of Juárez, Mexico, are visible beyond
El Paso's downtown skyline.

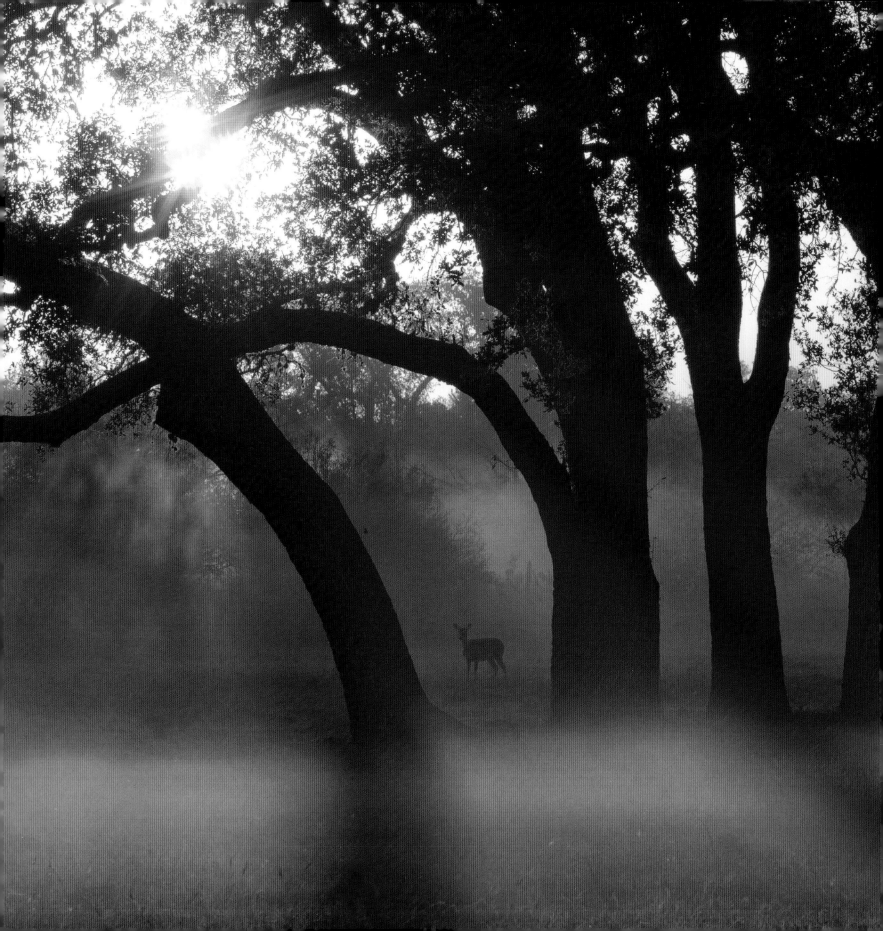

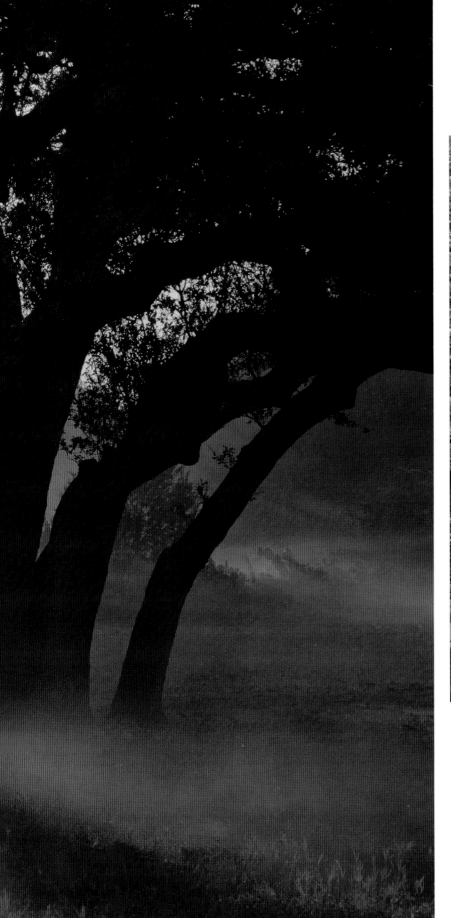

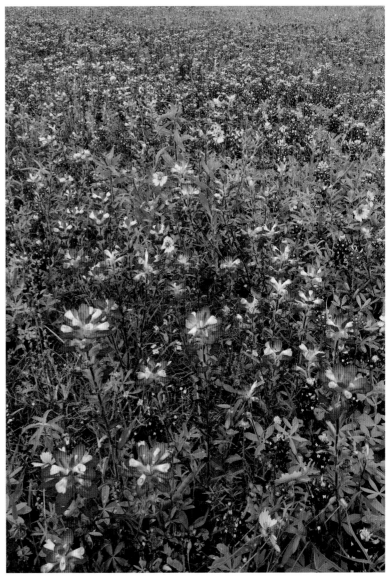

◄ A deer is barely visible in the mist between
live oak trees in Hays County in the Hill Country.
▲ Bluebonnets *(Lupinus texensis)*, Texas paintbrush *(Castilleja indivisa)*, and coreopsis *(Coreopsis sp.)* add brilliant
color along Boldt Road in DeWitt County.

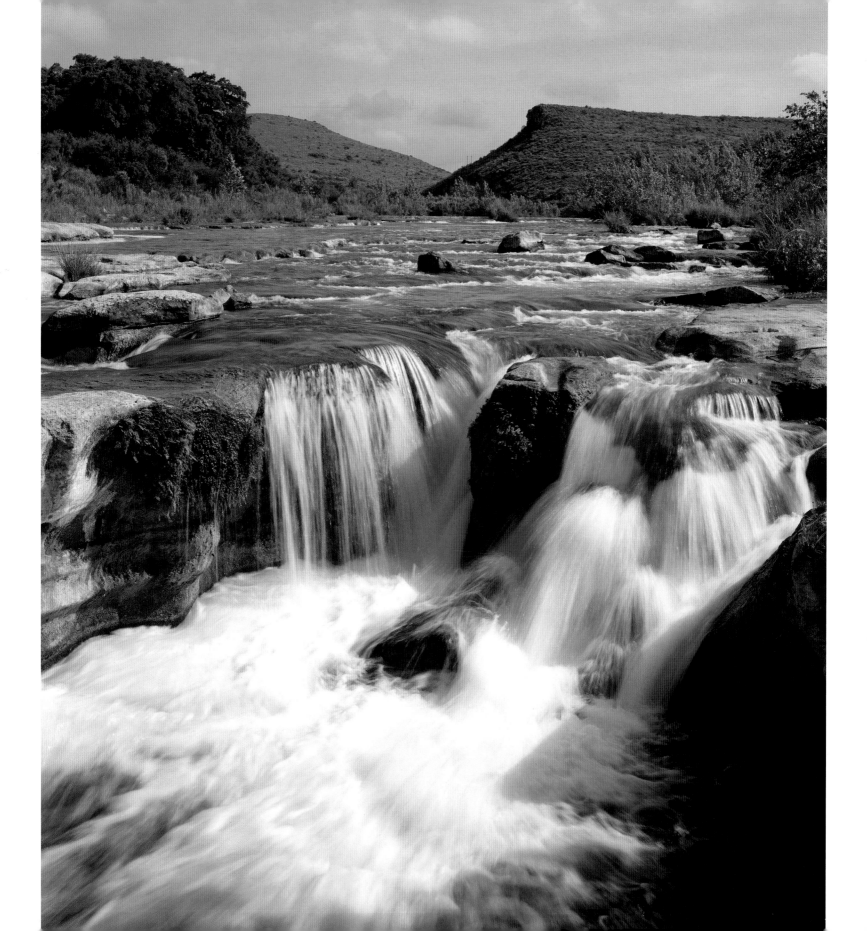

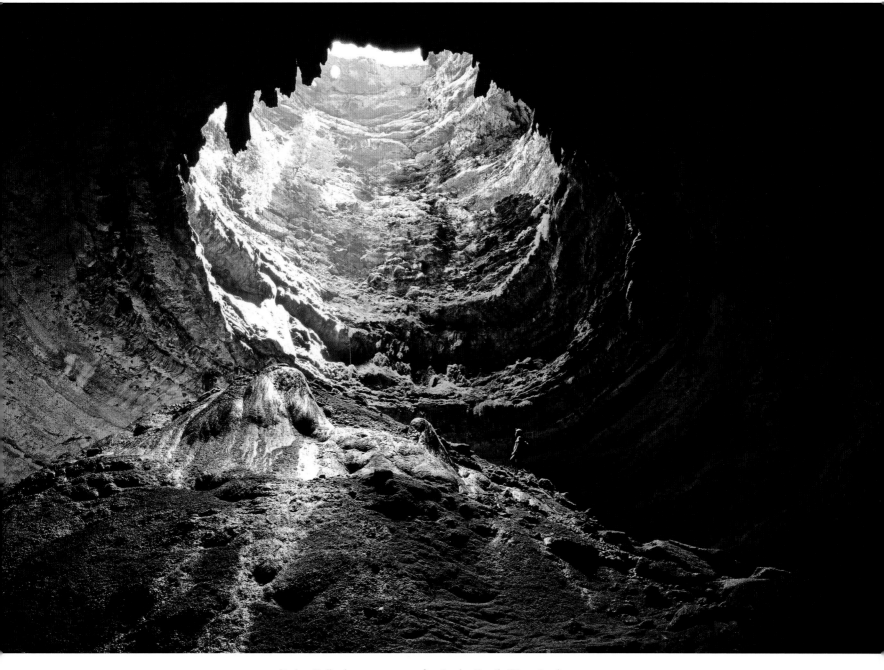

◄ Dolan Falls drops some ten feet in the Devils River, in the western
edge of the Hill Country. The river has some of the purest water in Texas.
▲ Devil's Sinkhole State Natural Area is a natural bat habitat, carved by water erosion.
The opening measures forty by sixty feet and drops some 400 feet below.
▶▶ Heather Ainsworth-Dobbins rests at an overlook in the
Chisos Mountains of Big Bend National Park.

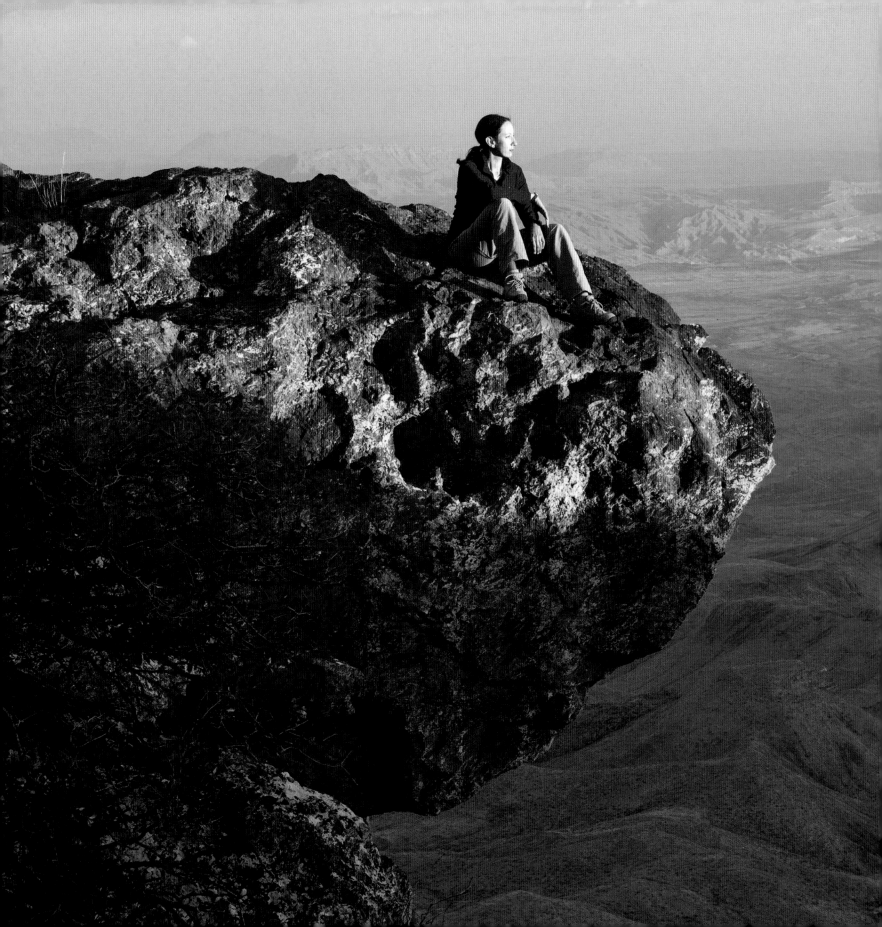

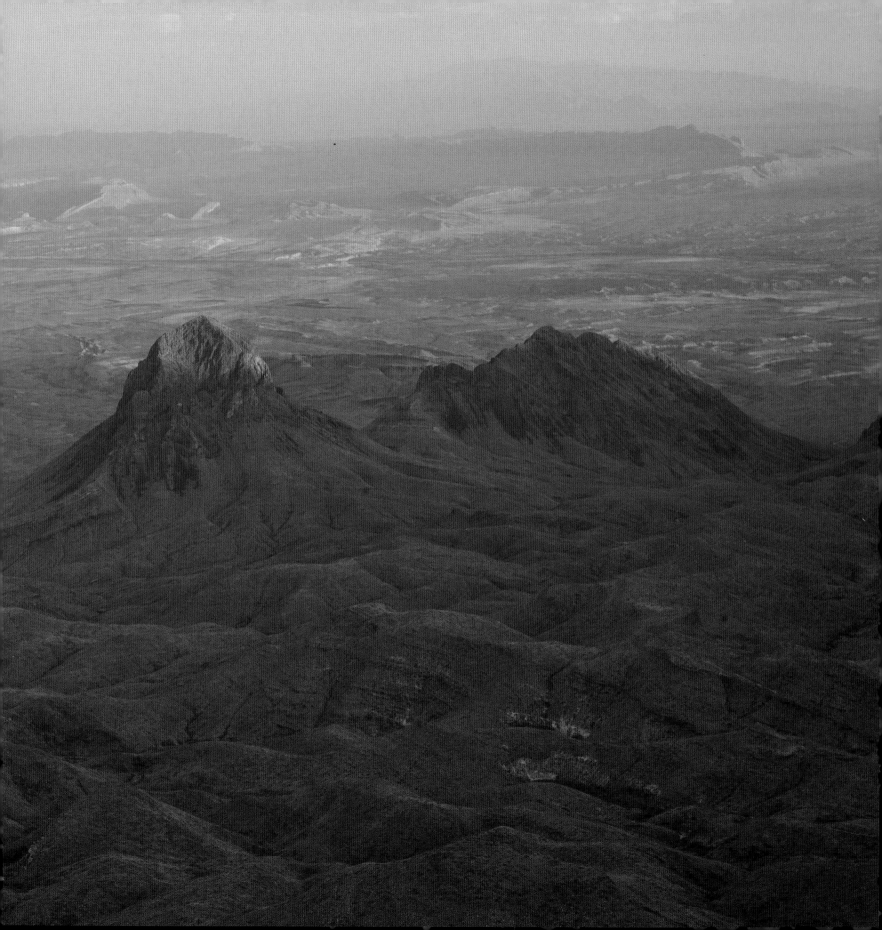

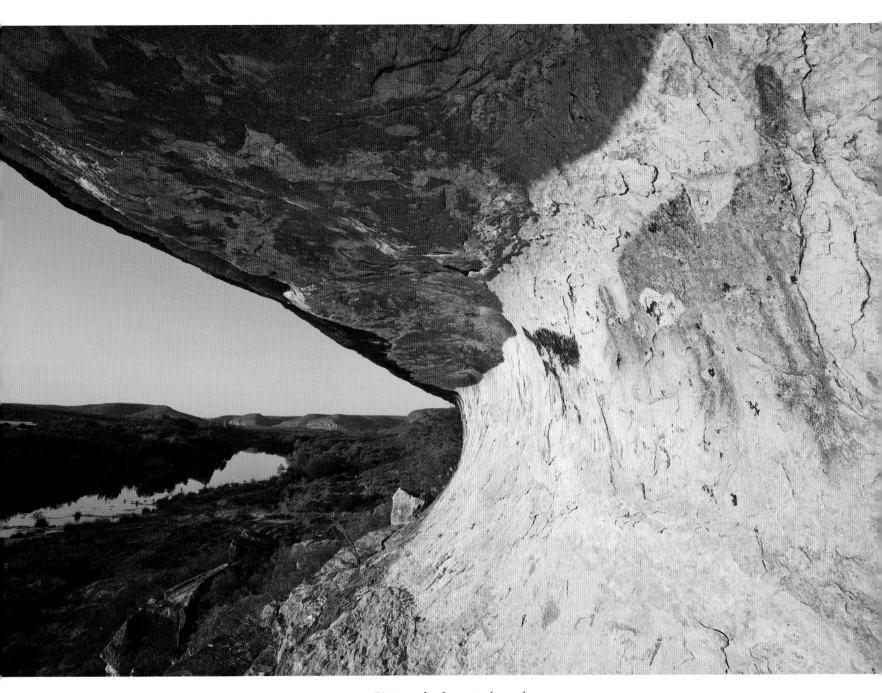

▲ Pictographs decorate the rock
walls at Turkey Bluff above the Devil's River
in Val Verde County. The Rock Art Foundation,
the Texas Parks and Wildlife Department, and area
ranchers work to preserve such pictographs.

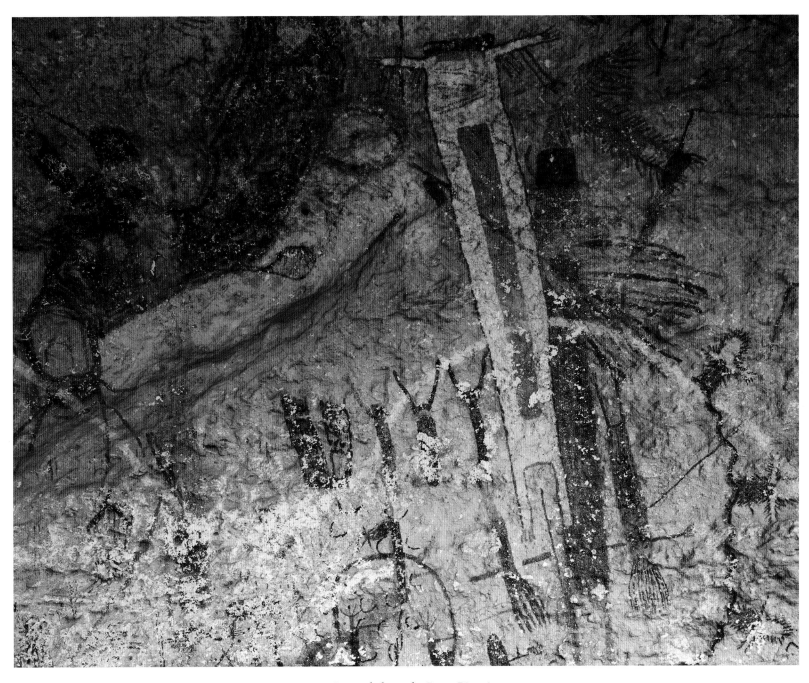

▲ Situated above the Pecos River in
Galloway White Shaman Preserve, shaman
pictographs may hint at the religious beliefs of
the prehistoric peoples of the region.

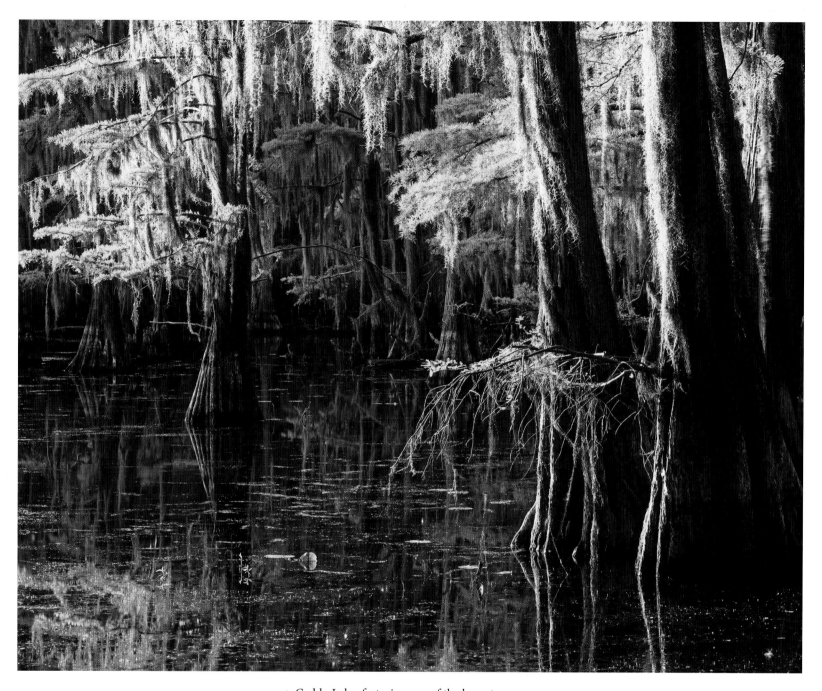

▲ Caddo Lake, featuring one of the largest cypress
forests in the world, was the only natural lake in Texas until
the early 1900s, when oil was discovered and the lake was dammed.
► A mother and daughter enjoy the view at Pedernales Falls State Park. Here
the Pedernales River cascades over a series of limestone ledges on its
path to joining the Colorado River. Occasional violent floods
scour the riverbed bare here of soil and vegetation.

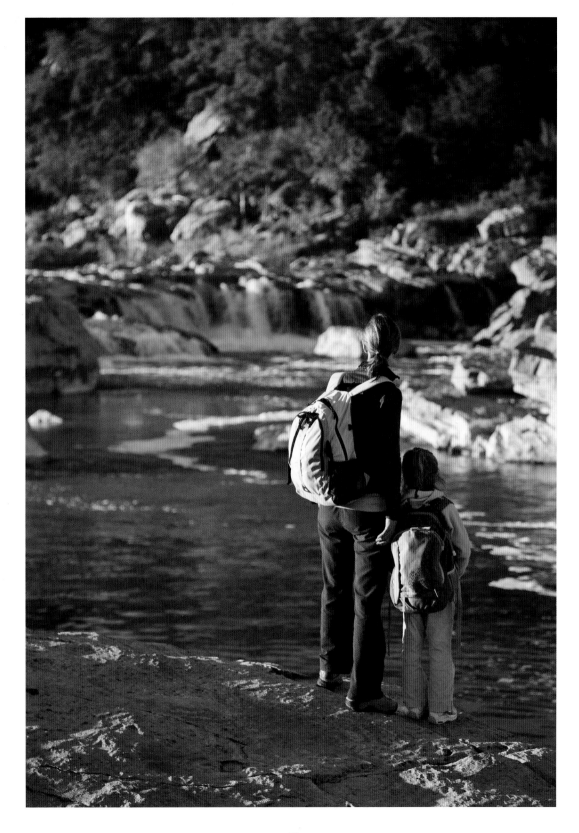

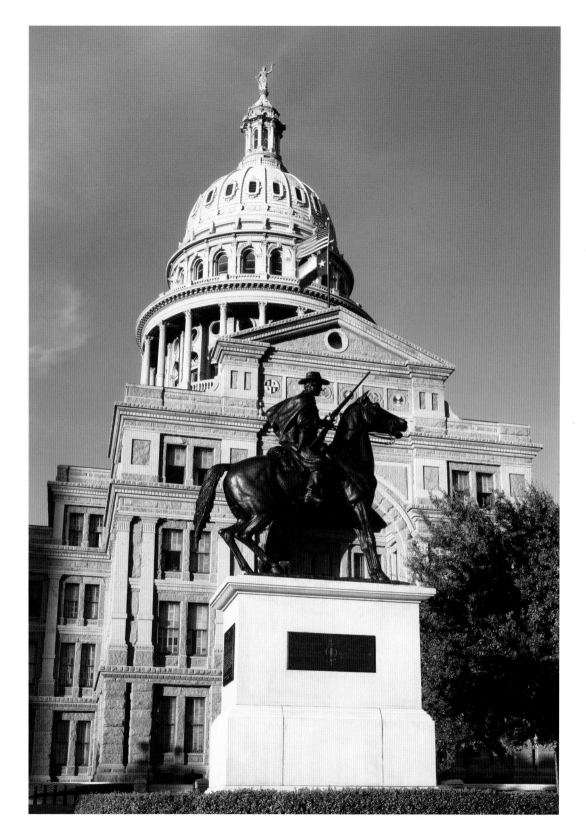

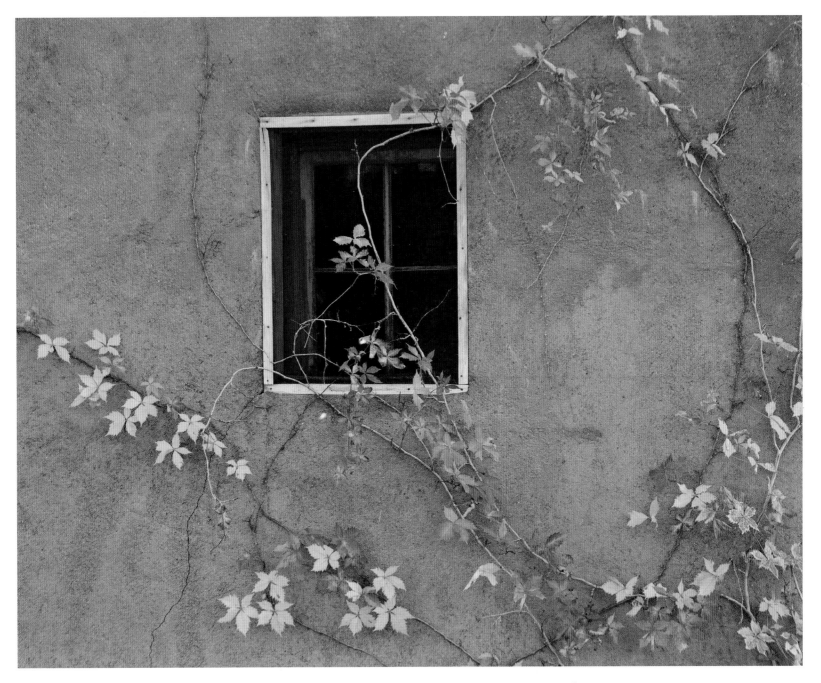

◄ A monument to Terry's Texas Rangers, a volunteer regiment of
the Confederate Army, sets off the State Capitol in Austin. The monument was
sculpted by Italian immigrant Pompeo Coppini, who created several Confederate memorials.
▲ Virginia creeper colors an old adobe wall on a ranch in the Chinati Mountains.
►► South Padre Island is part of a barrier island featuring the longest sand beach
in the United States and some 600 species of plants and wildflowers.

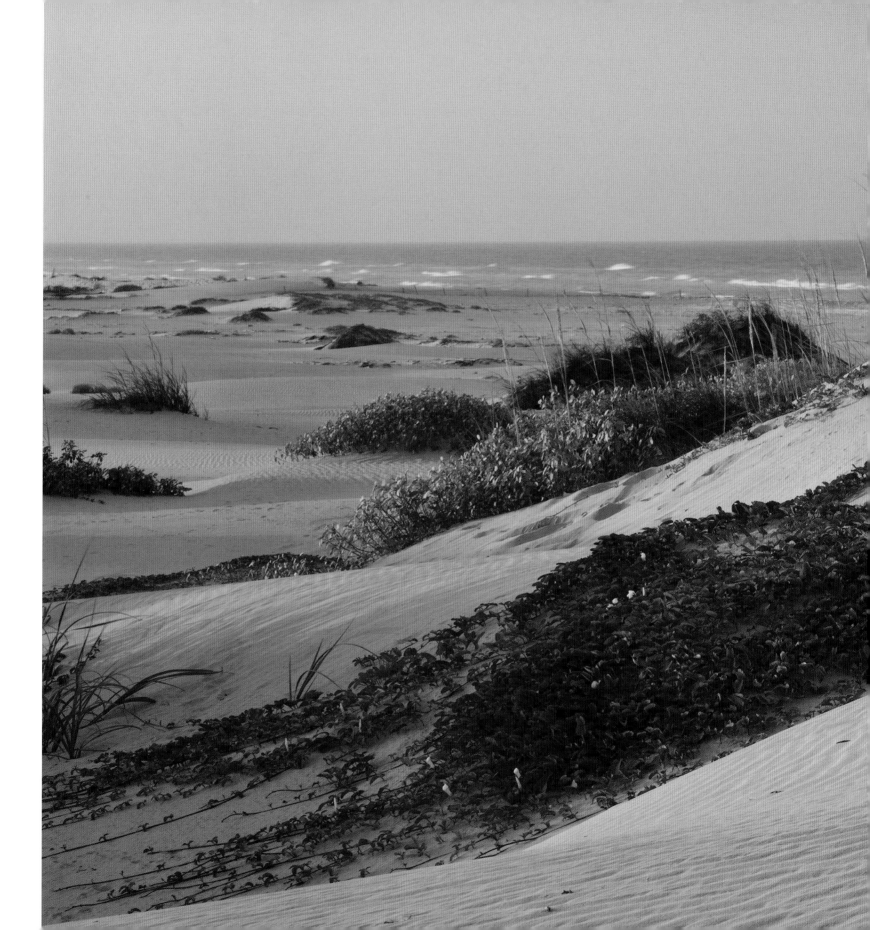

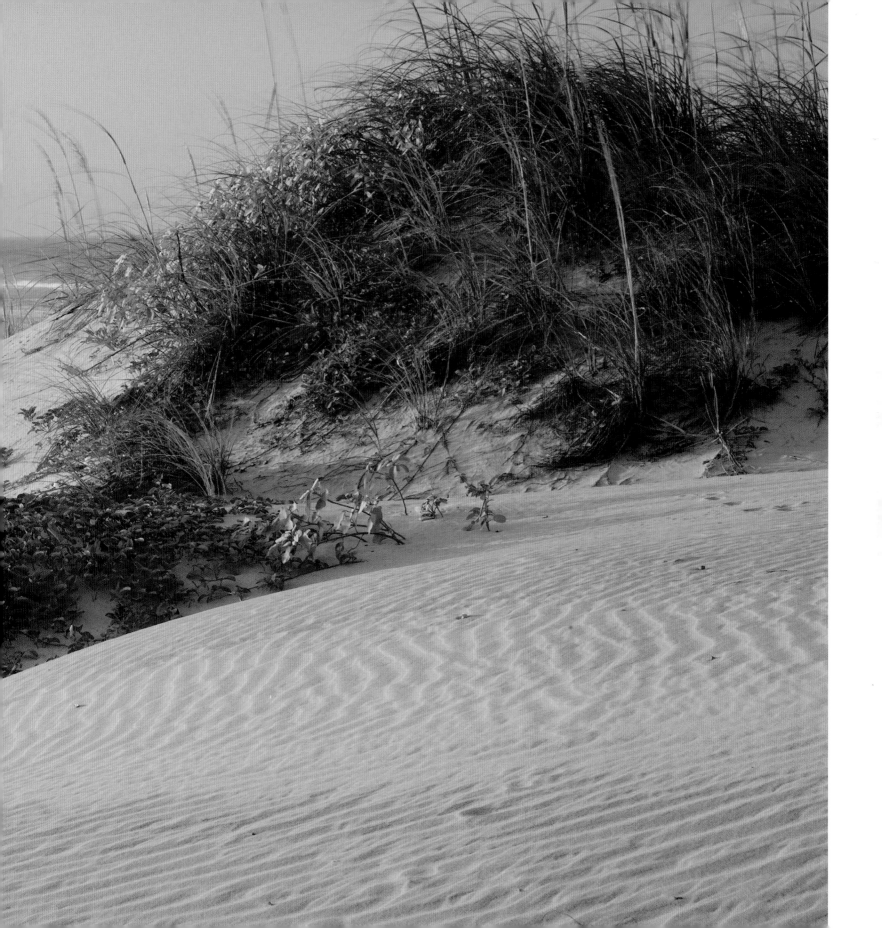

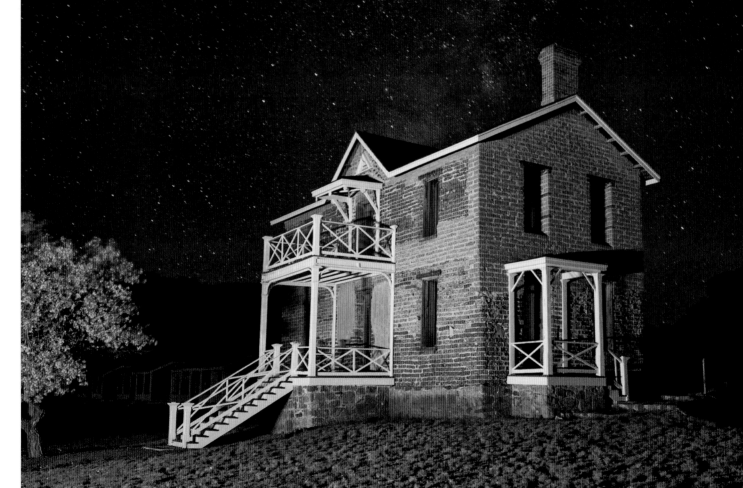

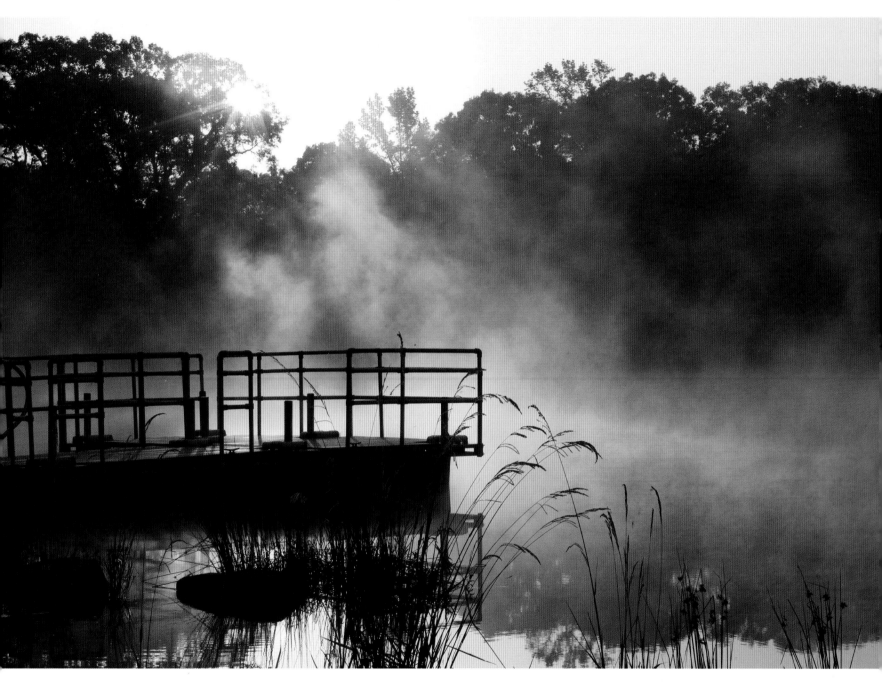

◄ A two-story officers quarters shows a bit of
historic Fort Davis National Historic Site. A survivor
of the Indian Wars, the fort was active from 1854 to 1891.
▲ Fort Boggy State Park's name comes from an 1840s log fort built
by early settlers on the bank of Boggy Creek. Morning mist
hovers over the park lake on a crisp spring morning.

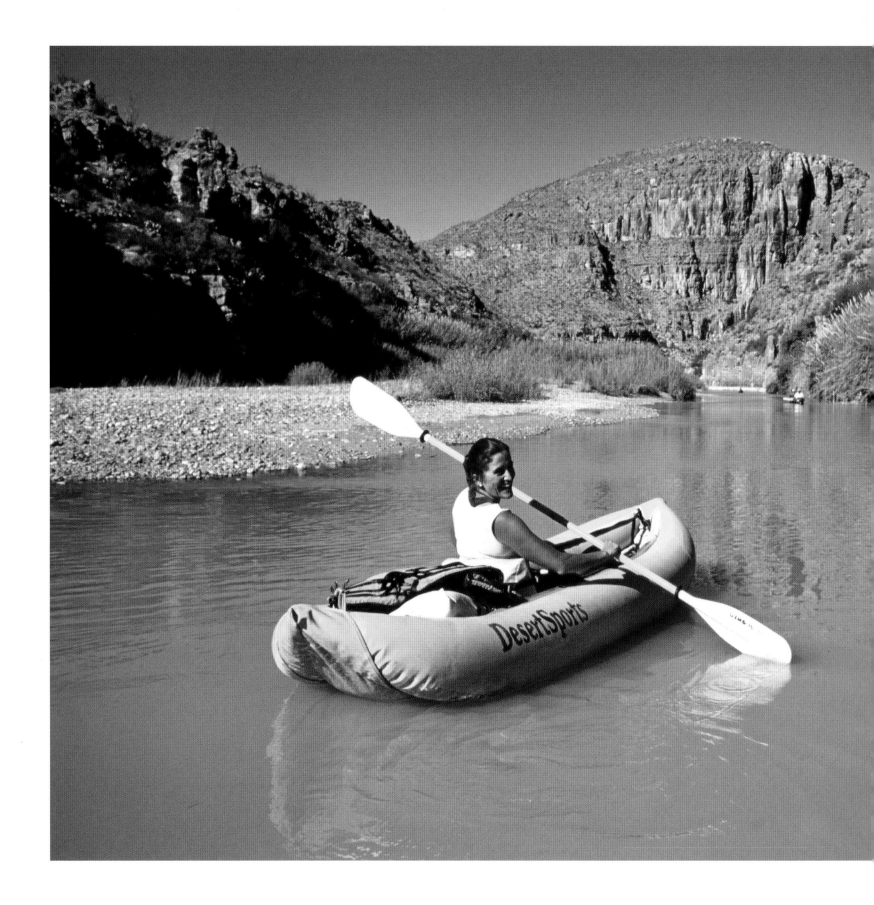

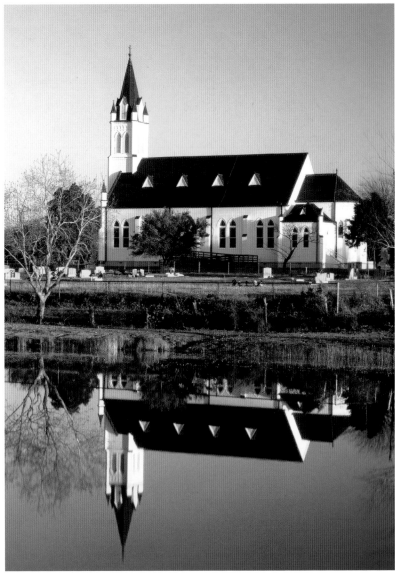

◄ The Rio Grande Wild and Scenic
River protects 196 miles of the Rio Grande. Here, Jen
Sjostedt paddles an inflatable kayak through the Lower Canyons.
▲ St. John the Baptist Catholic Church in Ammannsville is the third
St. John's to be built here. One of the Painted Churches of Fayette
County, the interior of St. Johns is painted a rosy pink.

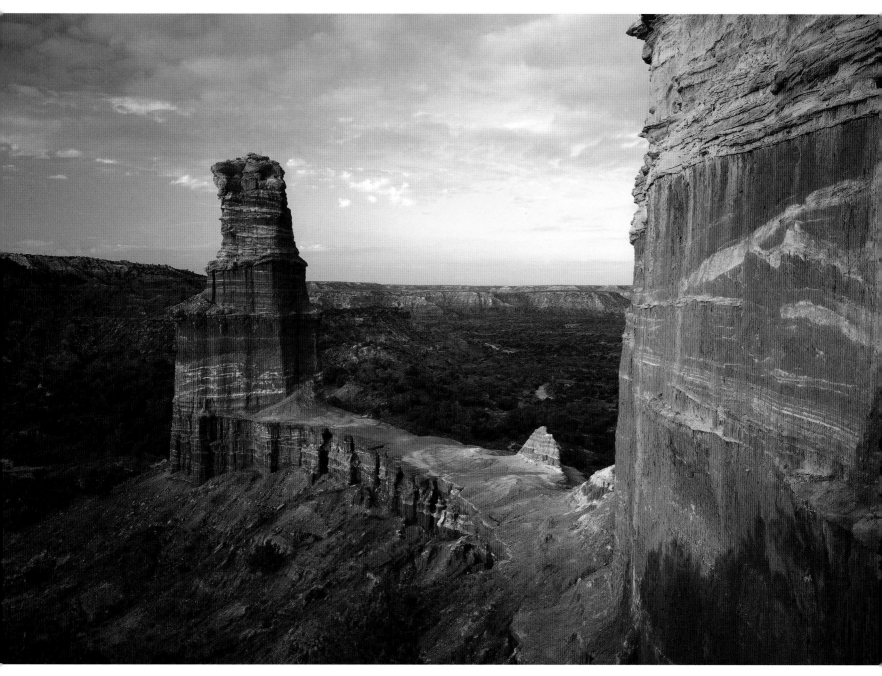

▲ The Lighthouse is a natural rock formation in Palo Duro Canyon State
Park. Water carved this formation out of soft sedimentary rocks over many thousands of years.
► All oceangoing traffic in and out of the port of Corpus Christi once traveled past the Aransas Pass Lighthouse
near Port Aransas. The lighthouse's original fourth-order Fresnel lens is displayed at the Port Aransas Museum.
►► The Hotel El Capitan, designed by renowned architect Henry Trost and built by Charles Bassett,
opened in 1930. In 2007, Lanna and Joe Duncan bought the property, which had been
converted to a bank in the 1970s, and completely restored it as a hotel.

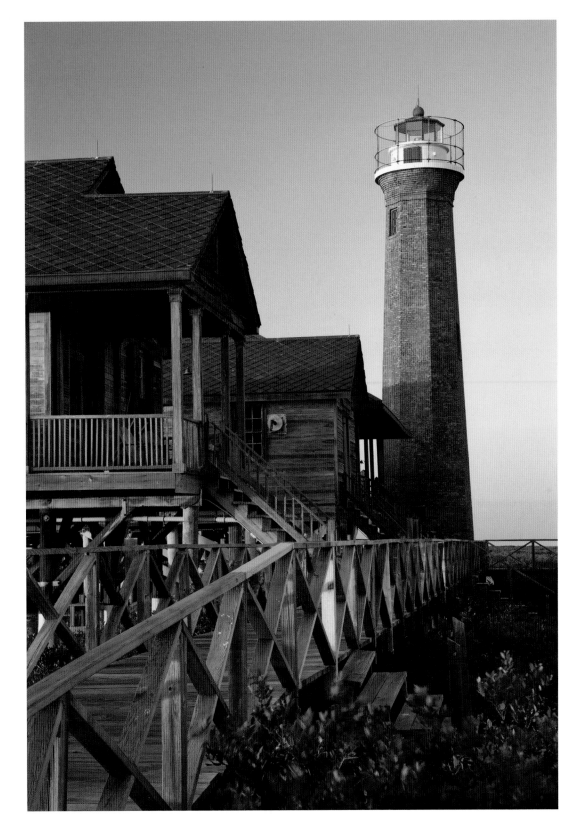

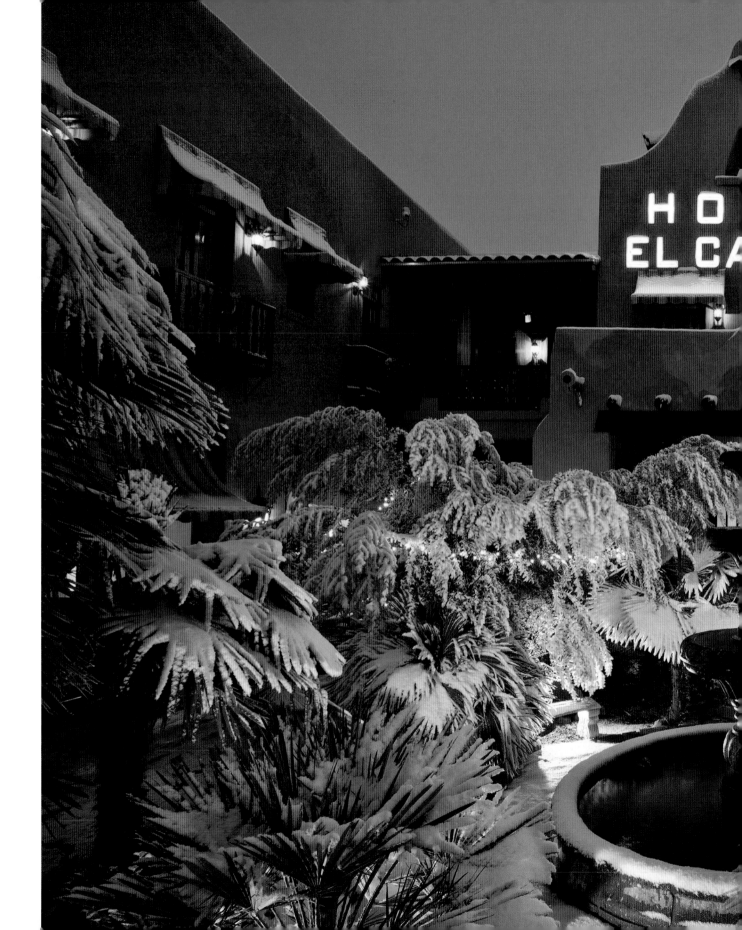

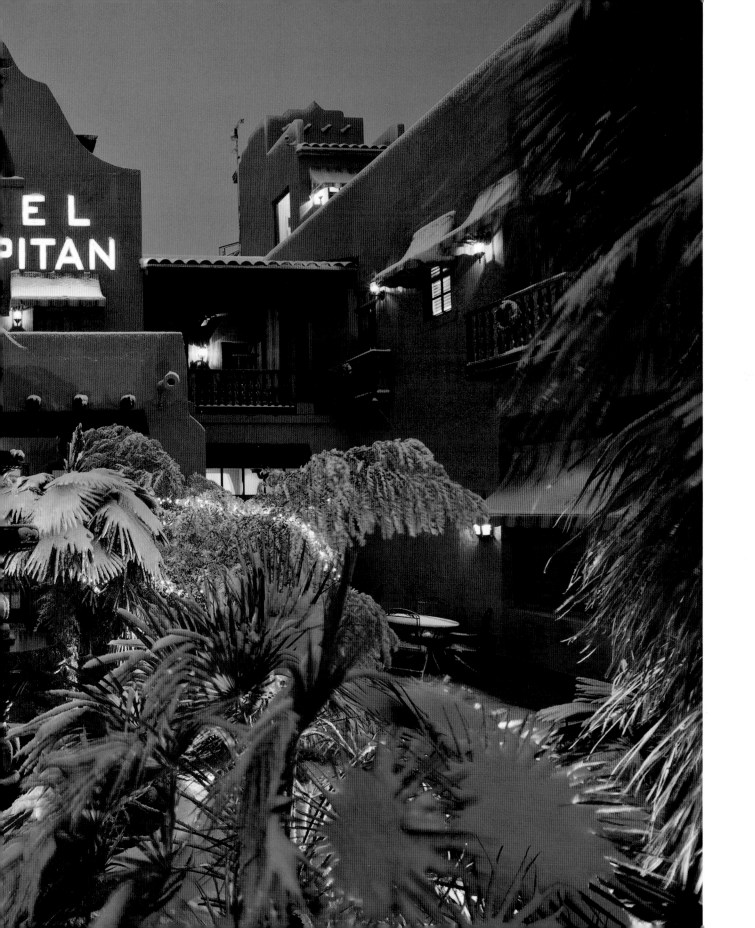

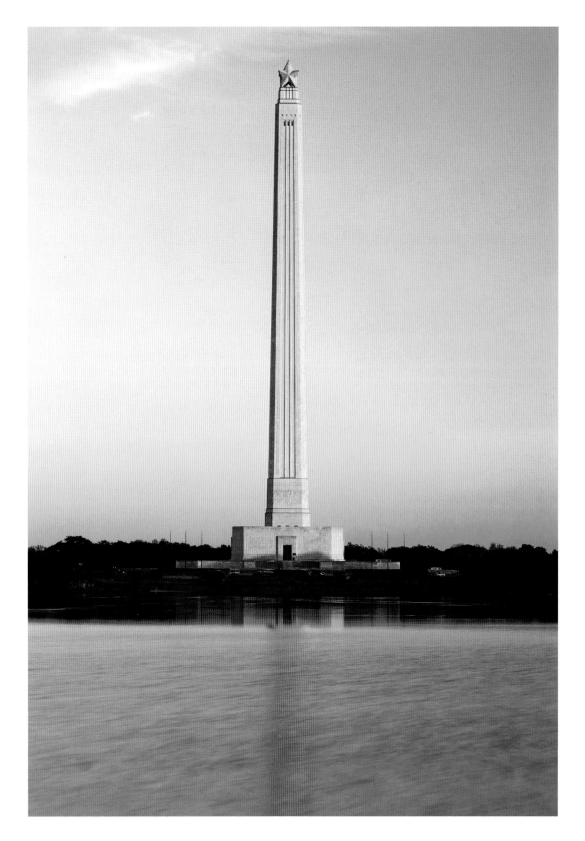

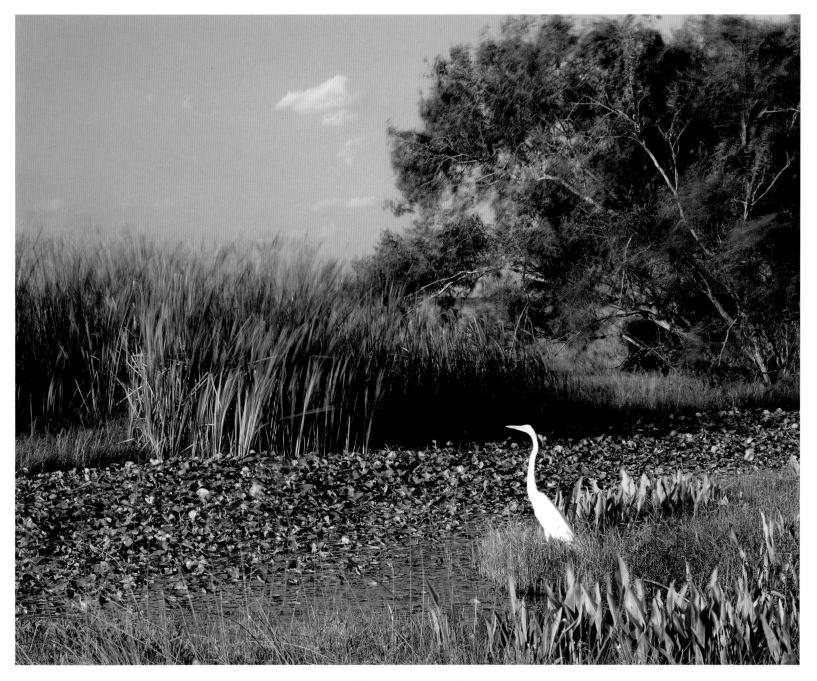

◀ Situated in San Jacinto Battleground
State Historic Site, the San Jacinto Monument
commemorates the decisive battle fought on April 21, 1836,
against Mexico. The outcome made Texas an independent nation.
▲ A common egret is just one of three hundred species of birds
that can be found at San Bernard National Wildlife Refuge.

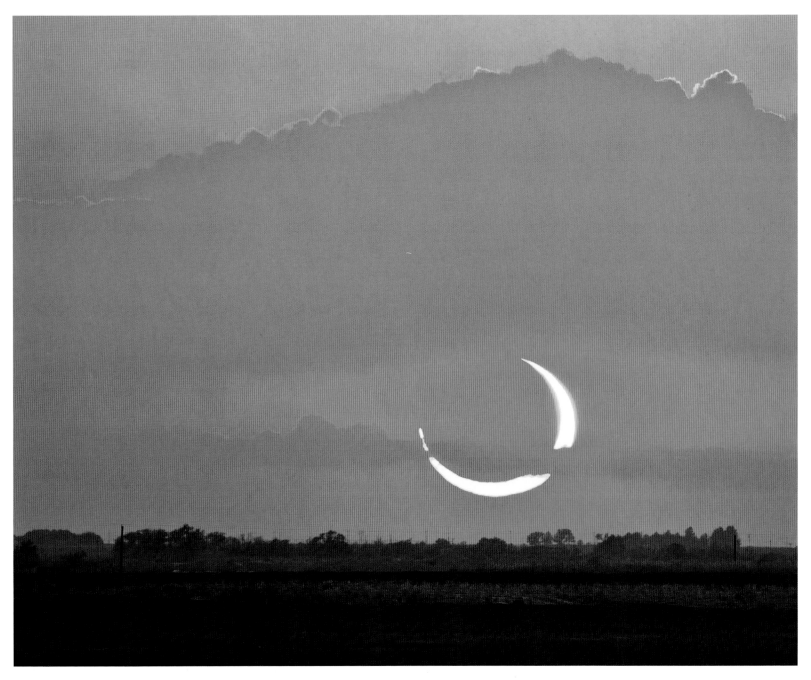

▲ An annular solar eclipse nearly obscures the sun in Terry County, in the Texas Panhandle. Originally settled by ranchers, Terry County is among the state leaders in cotton production, which generates more than 90 percent of the county's agricultural profits.
▶ Hiker April Pendleton rests on a lookout in Hill Country State Natural Area.

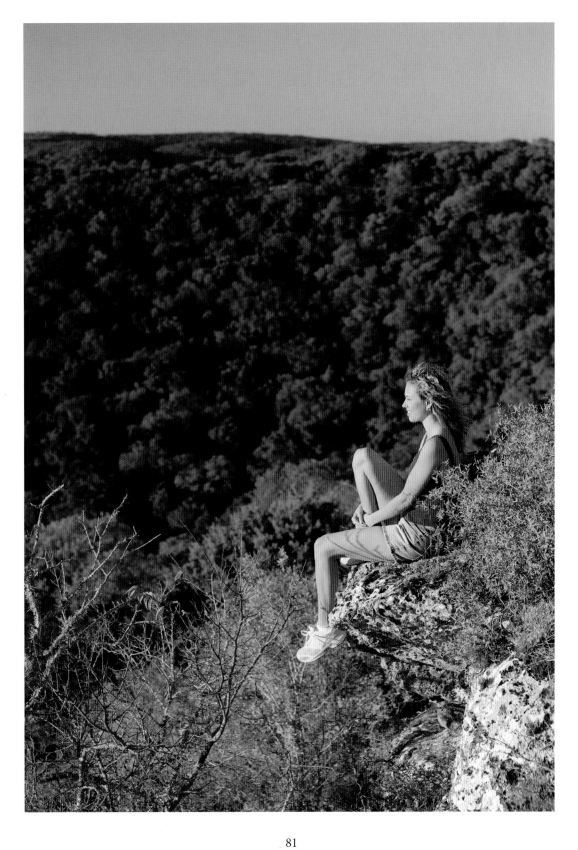

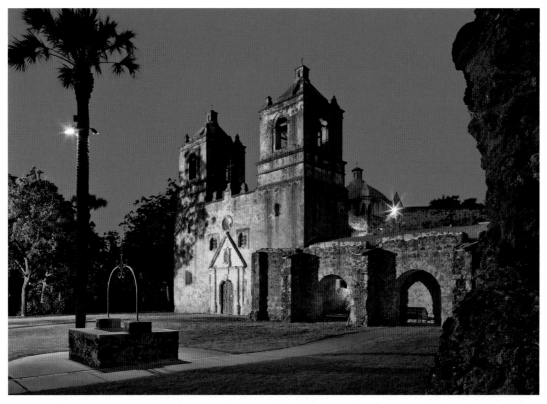

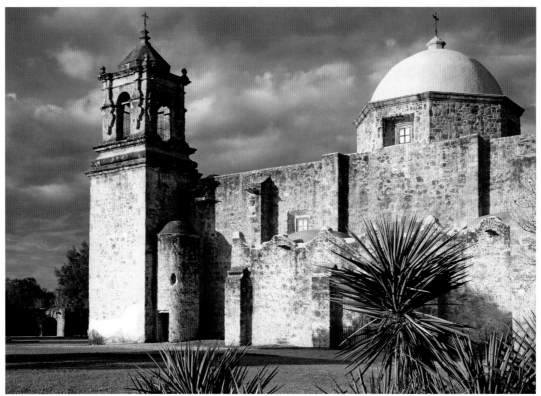

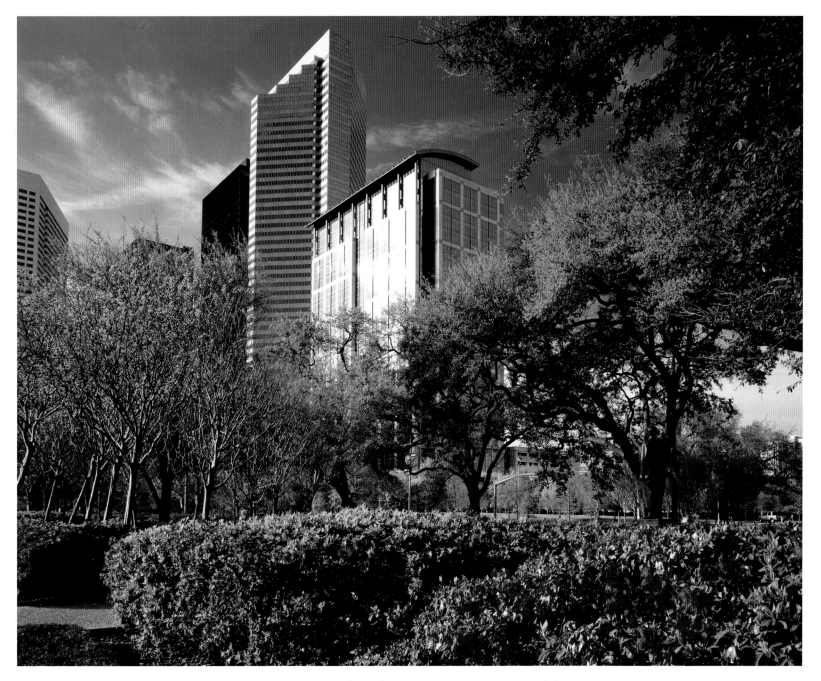

◄ TOP TO BOTTOM: ◗ Dedicated in 1755, Mission Concepción in San Antonio
was originally known as Mission Nuestra Señora de la Purísima Concepción de Acuña.
◗ Constructed along the San Antonio River in 1720, Mission San José was intended to
serve the Coahuiltecan Indians. Rooms for 350 Indians were built into the walls.
▲ Founded in 1836, Houston is the biggest city in Texas and is second only
to New York in the number of Fortune 500 company headquarters.
►► A gas well in Lavaca County reaches about 11,300 feet deep.

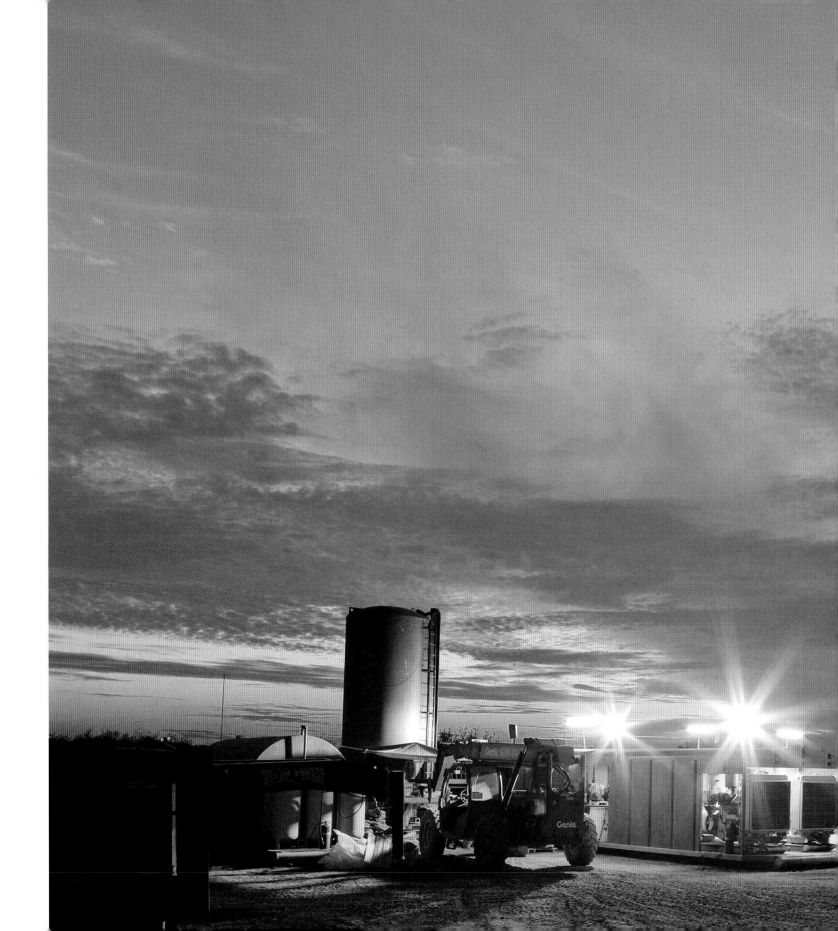

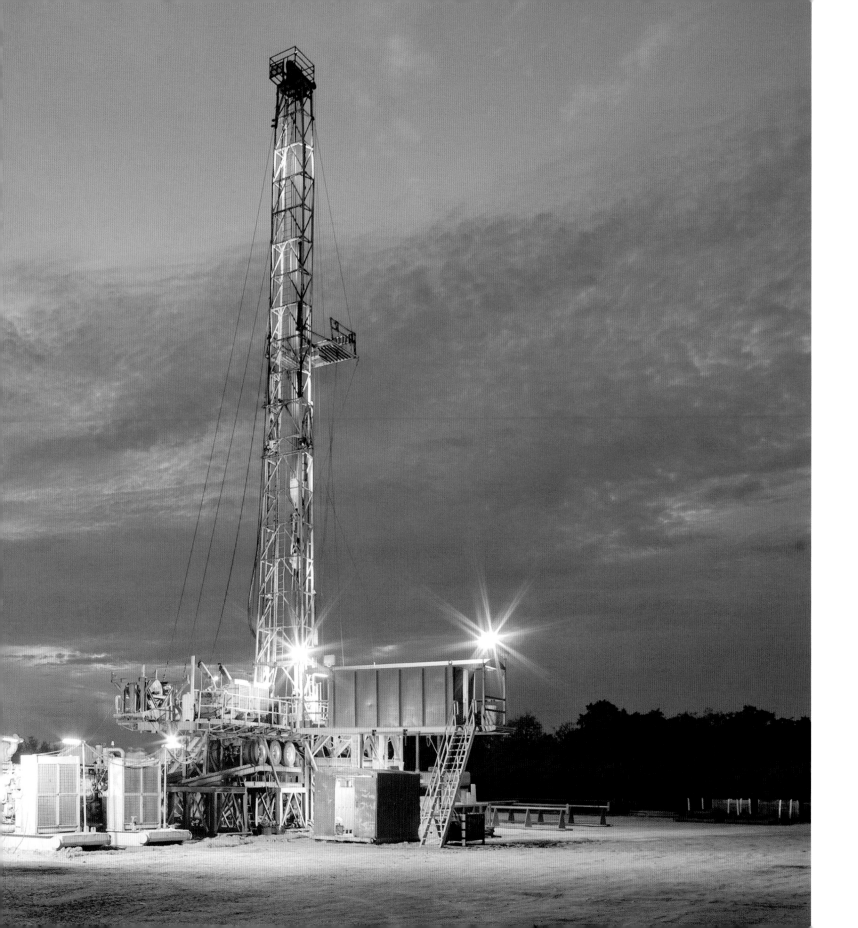

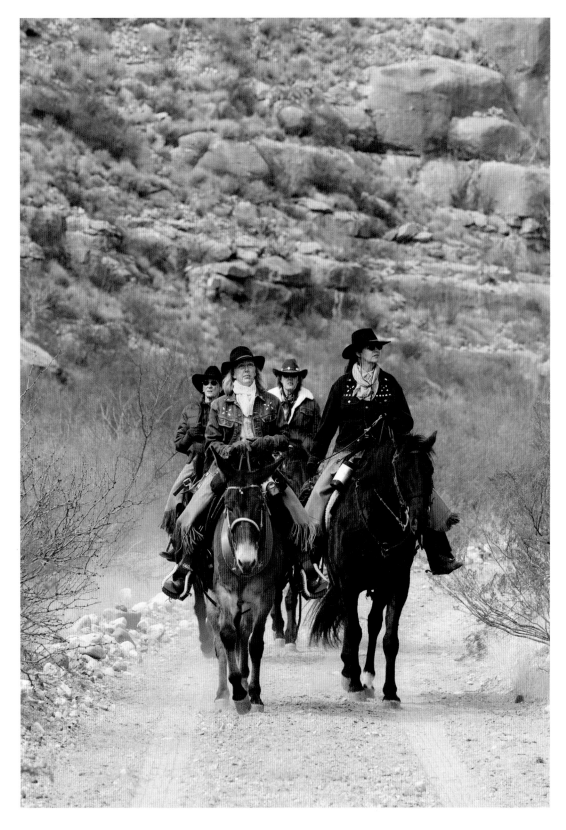

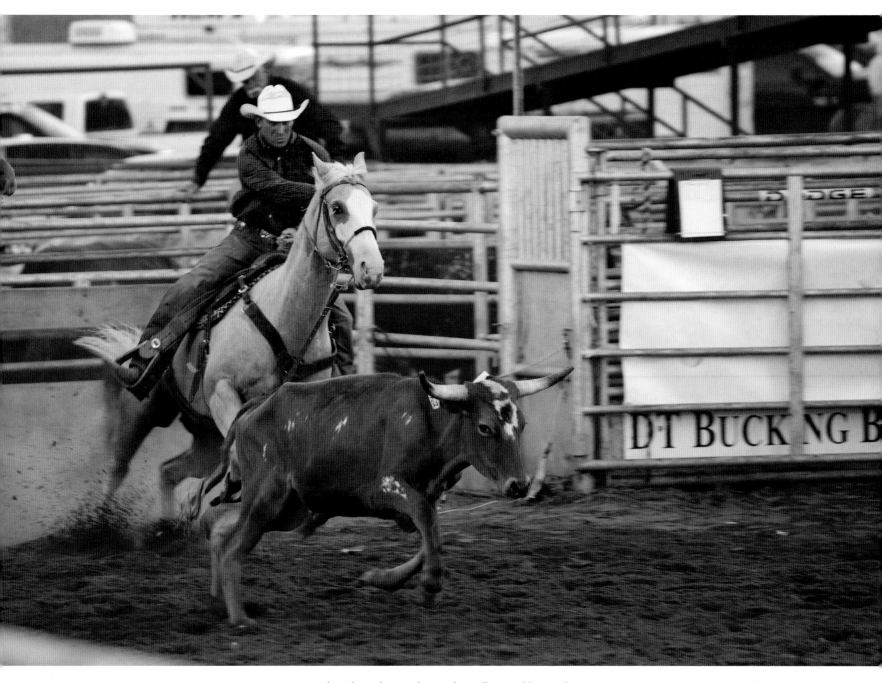

◀ Rhonda Cole, Sandy Smith, Milly Franklin, and
Nelda French ride a trail in Maravillas Canyon on the Stillwell Ranch.
▲ The Wimberley Rodeo ranks as one of the largest outdoor rodeos in the world.
Events include Tie Down Calf Roping (seen here), along with Bareback Bronc
Riding, Women's Breakaway Roping, Saddle Bronc Riding, Women's
Barrel Racing, Bull Riding, and other competitions.

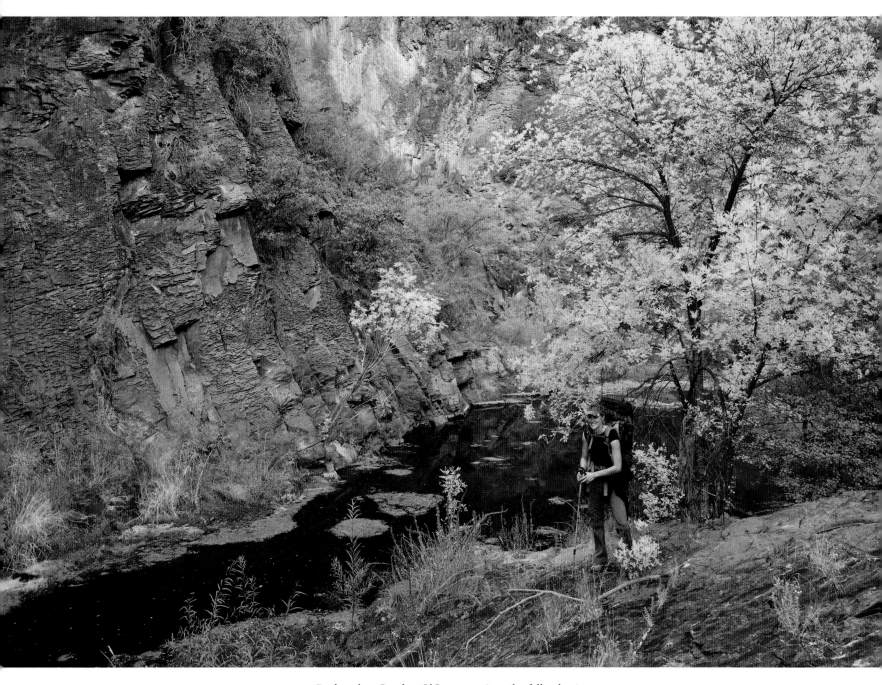

▲ Backpacker Carolyn O'Conner enjoys the fall color in
Madera Canyon, the Nature Conservancy's Davis Mountains
Preserve. The preserve helps protect 33,000 acres of biologically
diverse and scenic country.

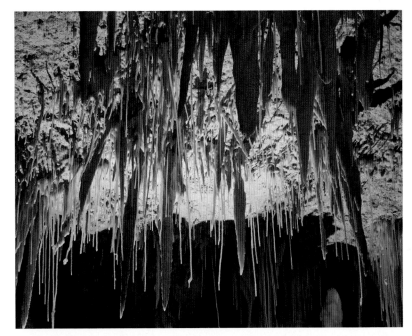

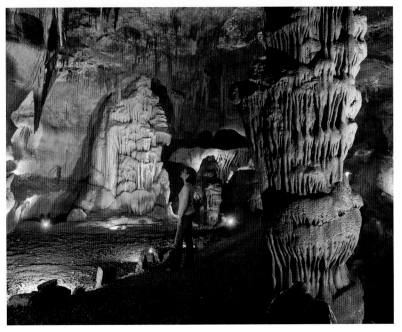

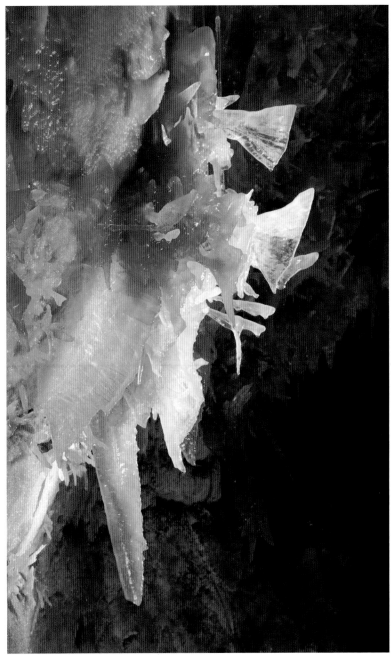

▲ CLOCKWISE FROM TOP LEFT: ● The Broom Closet, a chamber in Natural Bridge Caverns, showcases stalactites, formations that hang from the ceiling. The ones that grow from the floor are stalagmites. ● Helictites, shown here in Caverns of Sonora, are irregular stalactites with branching convolutions or spines. ● Annette Pauling looks at the formations in Cave Without a Name, situated in Kendall County. Columns form when stalactites and stalagmites meet.

▲ A rock ledge at Alibates Flint Quarries National Monument sports a petroglyph of a turtle. A petroglyph is actually a shape carved into rock, as opposed to a pictograph, which is painted on the surface of the rock. The quarries were dug by hand a thousand years ago. However, gathering flint from the mesa has taken place for 13,000 years.

► Spring-fed Gorman Falls drops some sixty feet in Colorado Bend State Park.

►► The marina at Corpus Christi sleeps in morning fog.

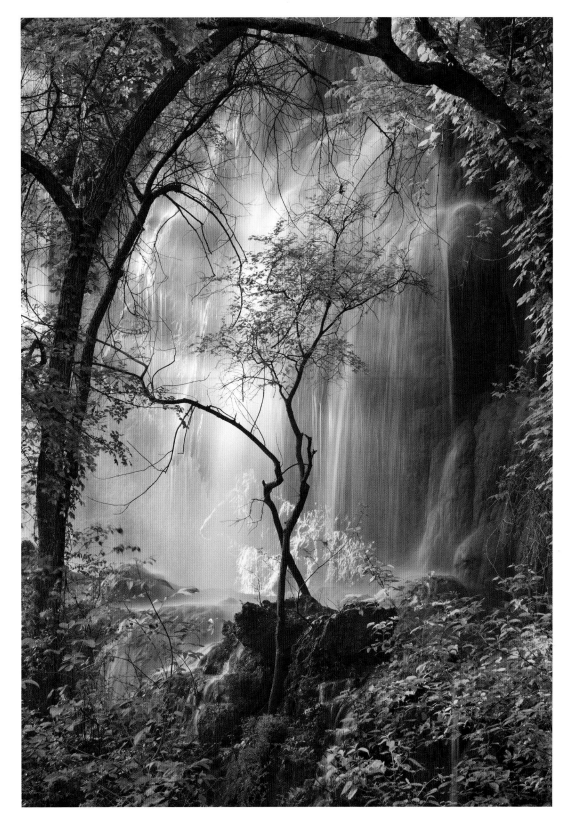

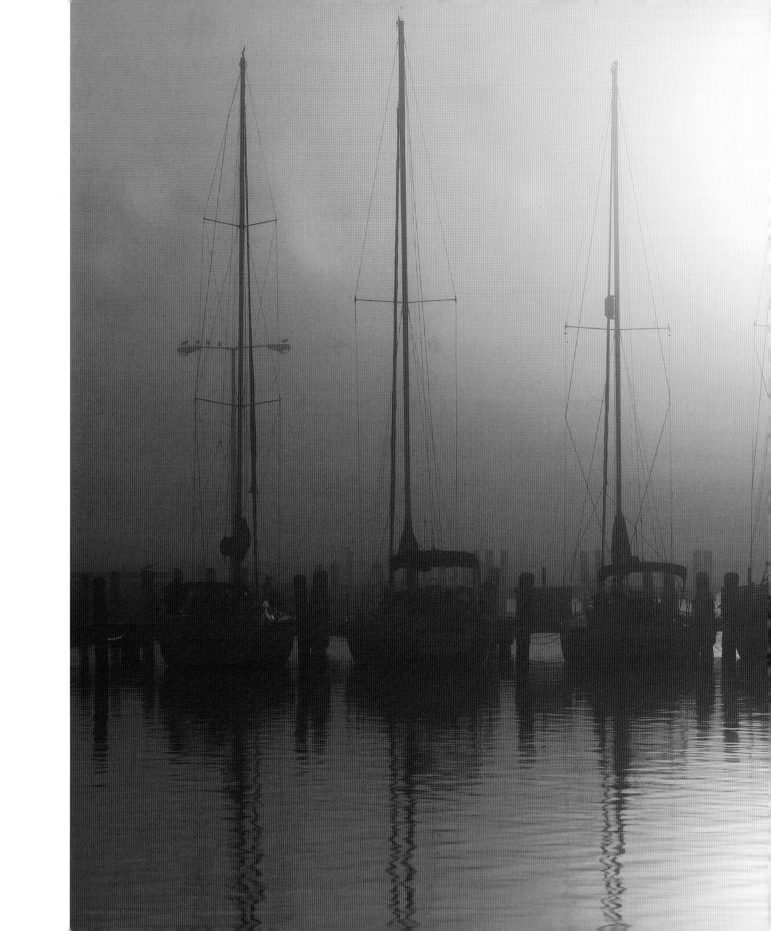

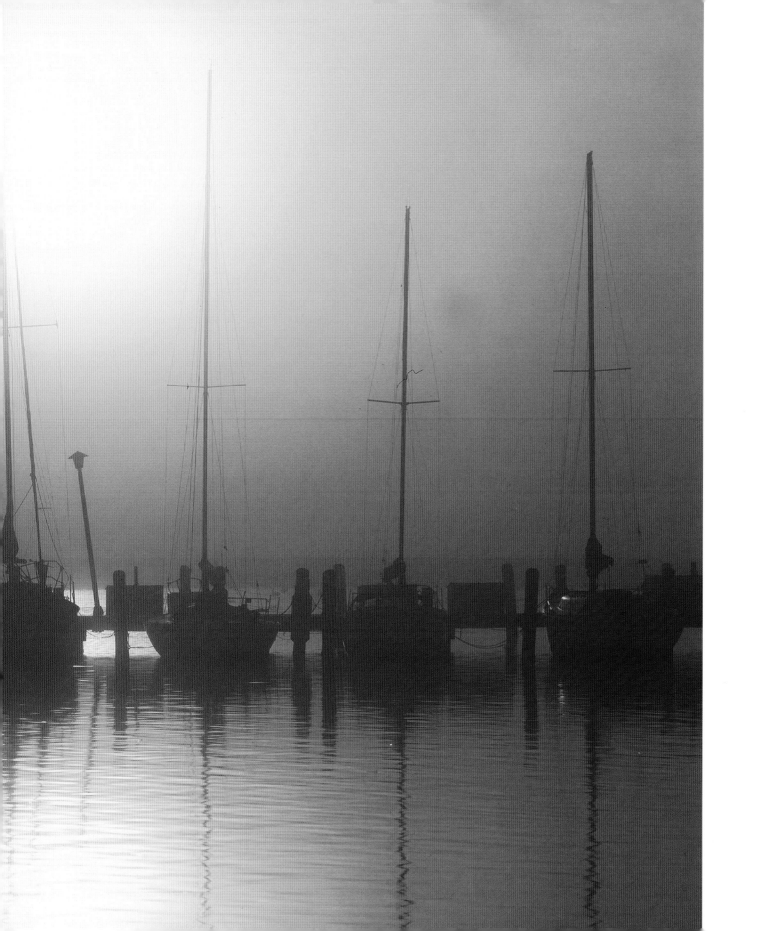

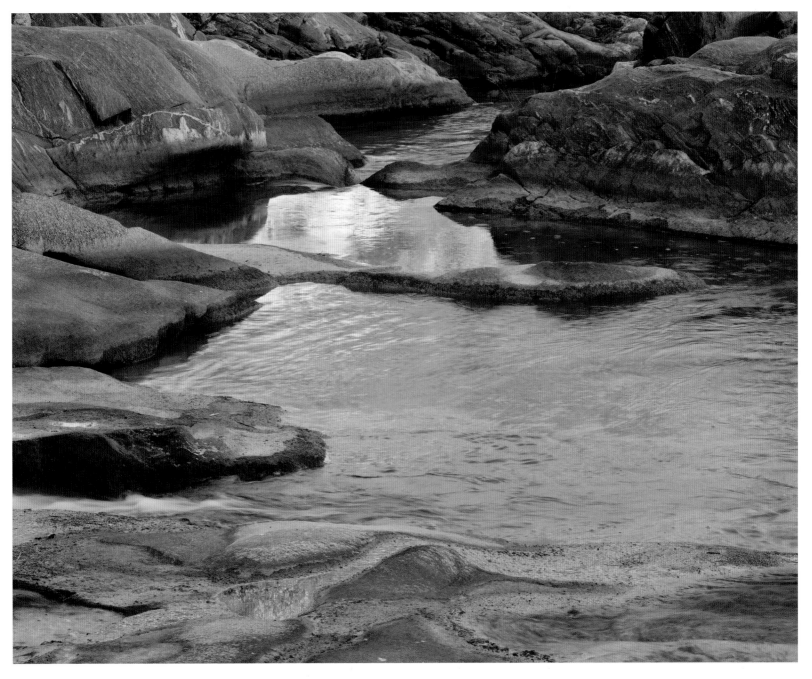

◄ Wildflowers—phlox *(Phlox drummondii)*, bluebonnets *(Lupinus texensis)*,
Texas groundsel *(Senecio ampullaceus)*, and Texas paintbrush *(Castilleja indivisa)*—
transform an old barn in Guadalupe County into a thing of beauty.
▲ Cascades and waterfalls mark Crabapple Creek Canyon in
the Hill Country's Gillespie County.

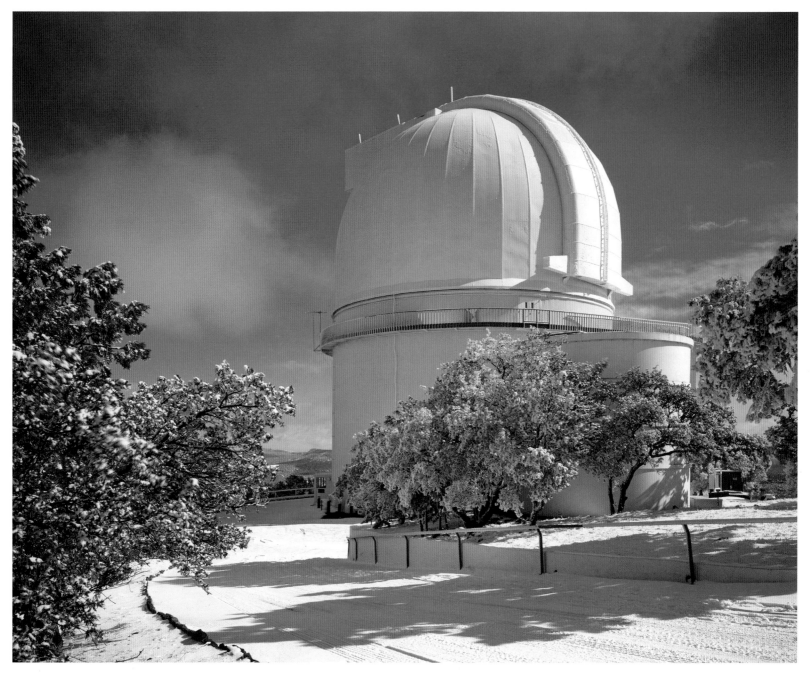

▲ Winter blankets McDonald Observatory
atop Mount Locke in the Davis Mountains of West Texas. Ten
to twelve times each year, typically on the Wednesday nearest the full
moon, the 107-inch Harlan J. Smith Telescope is opened for public viewing.
▶ Usually multi-trunked, a Texas madrone tree reveals a smooth,
polished inner bark after the outer bark has peeled off.

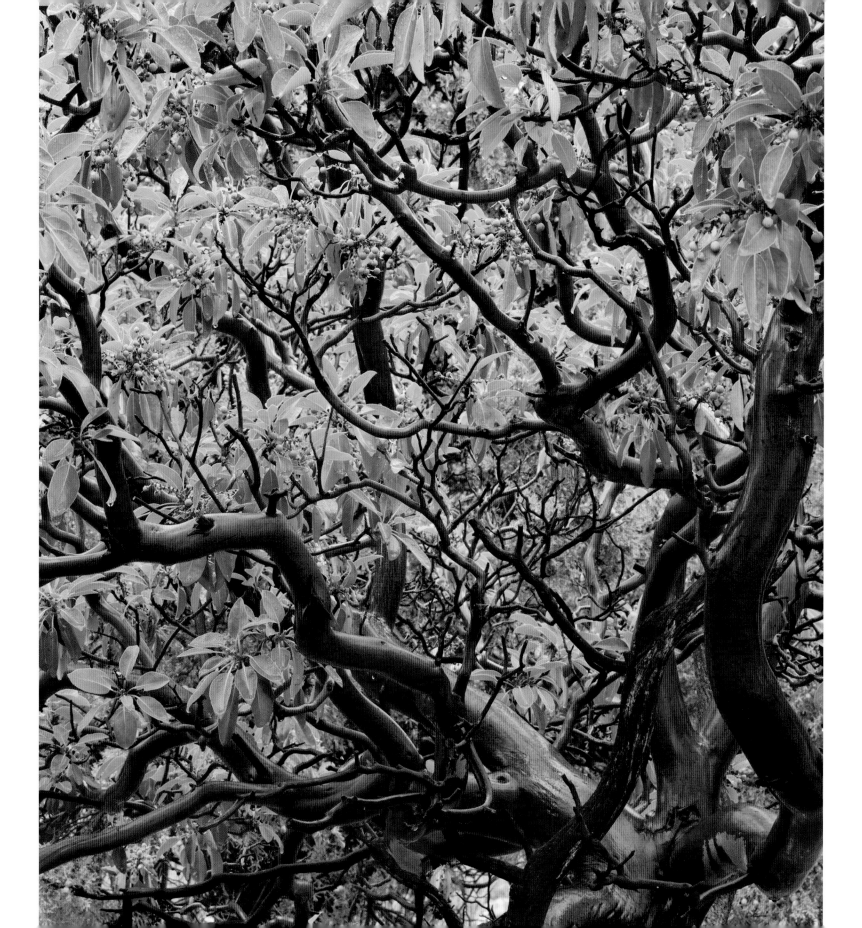

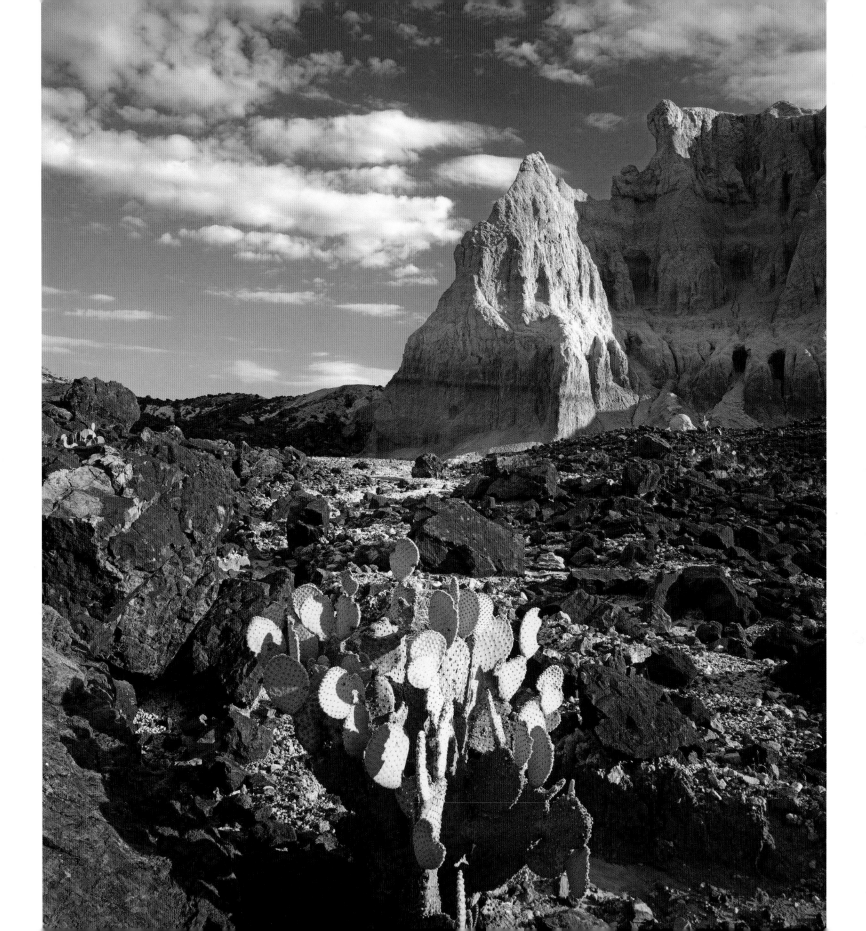

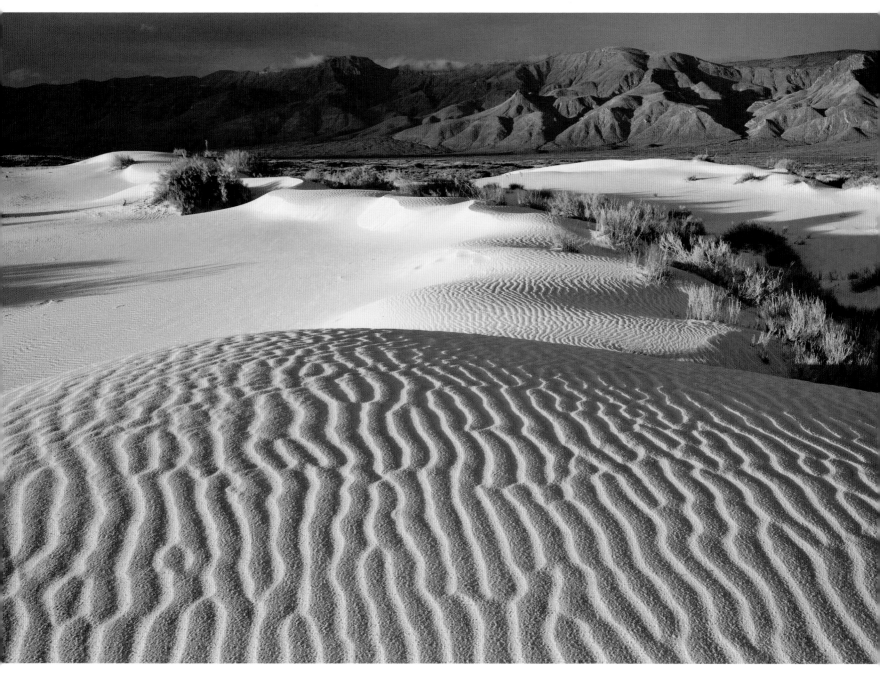

◄ Blind prickly pear *(Opunta rufida)* thrives
in eroded volcanic tuff and basalt boulders in Big Bend
National Park. Prickly pear pads are edible but be careful of the spines!
▲ Rippled gypsum sand dunes almost mirror the mountain chain
rising beyond in Guadalupe Mountains National Park.
The park encompasses more than 86,000 acres.

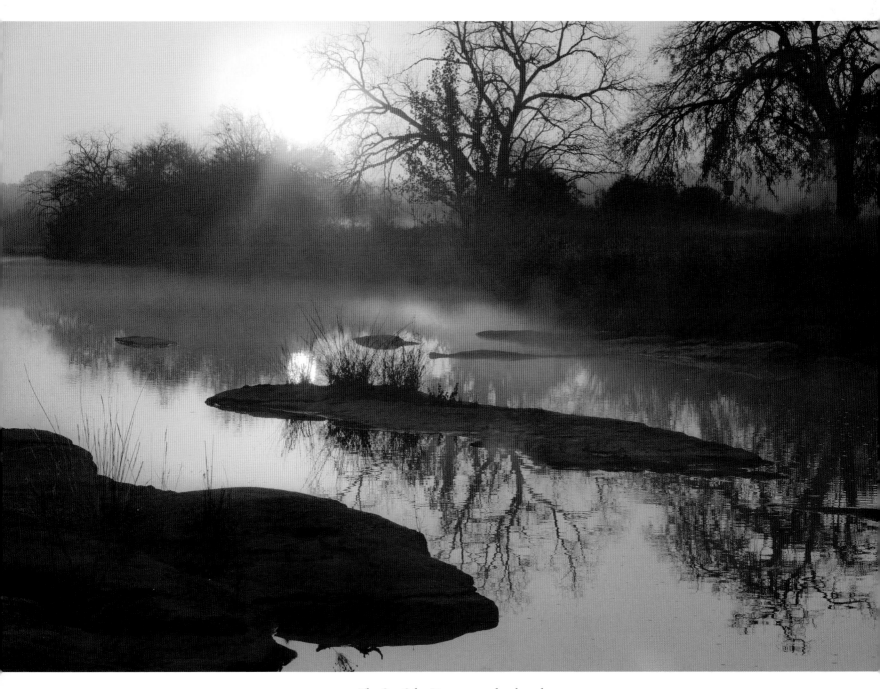

▲ The San Saba River, an undeveloped
and scenic waterway, has its beginnings in the North
Valley and Middle Valley Prongs. After the two prongs meet
near Fort McKavett, the river continues on for some
140 miles before it joins the Colorado River.

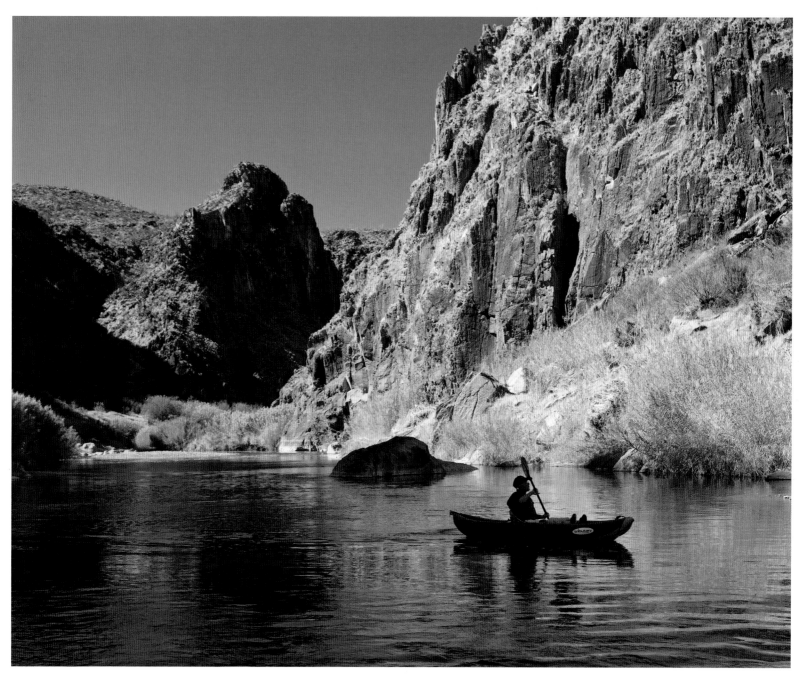

▲ Joe Nick Patoski paddles his kayak in the
Rio Grande in Big Bend Ranch State Park's Colorado
Canyon. The river cuts through thick layers of volcanic rock along
the south boundary of the park. Mexico lies across the river.

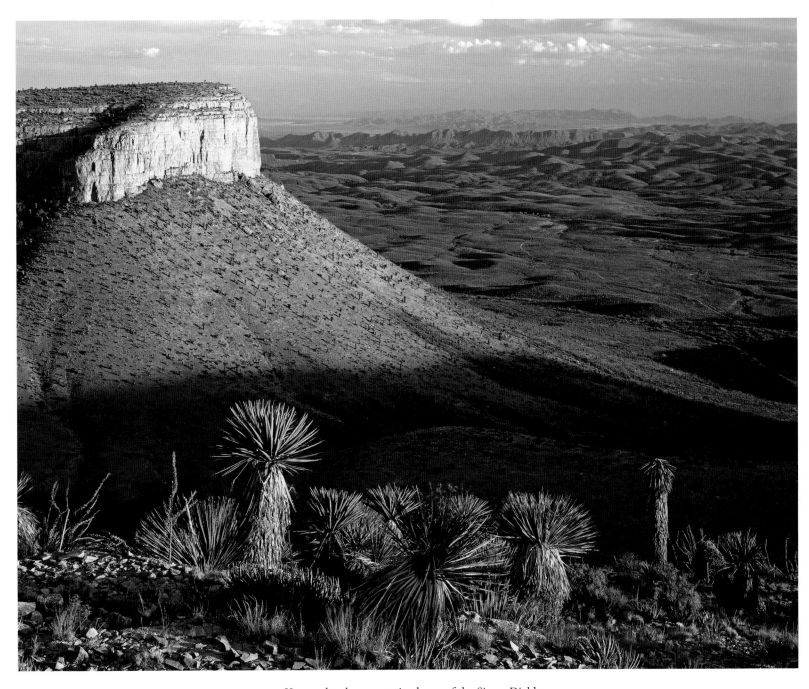

▲ Yuccas dot the mountain slopes of the Sierra Diablo.
Ranchers and the Texas Parks and Wildlife Department have
worked for many years to restore the desert bighorn
sheep to these West Texas mountains.

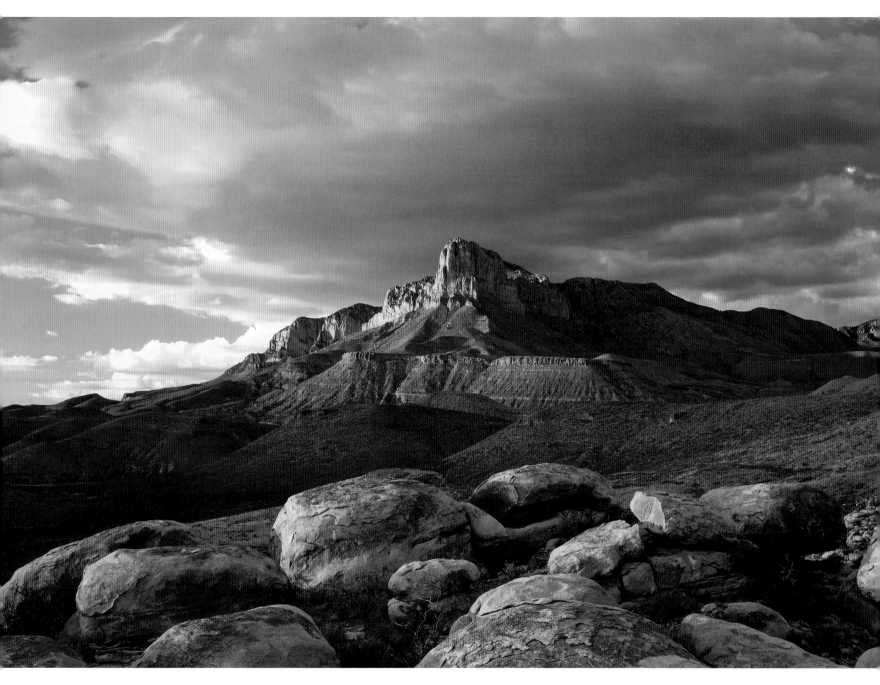

▲ Boulders are strewn across a hillside
in Guadalupe Mountains National Park.
El Capitan Peak rises 8,085 feet in the background.
Behind it rises Guadalupe Peak, the highest peak in Texas
at 8,751 feet. The peaks served travelers as
beacons for hundreds of years.

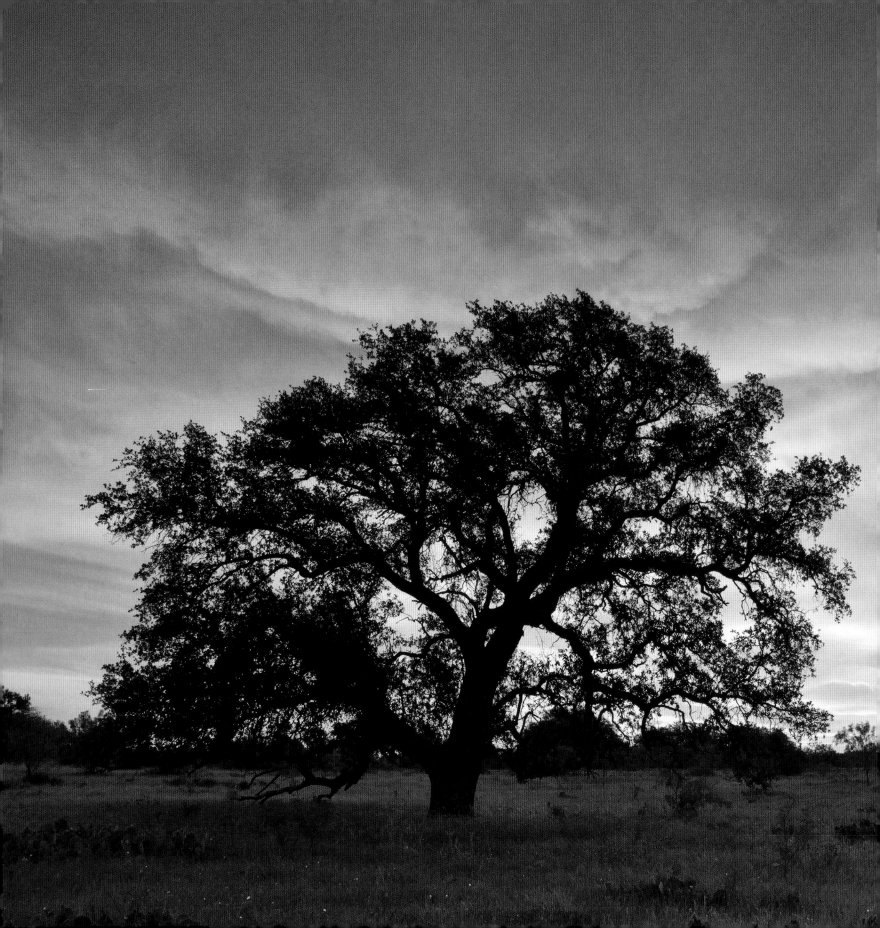

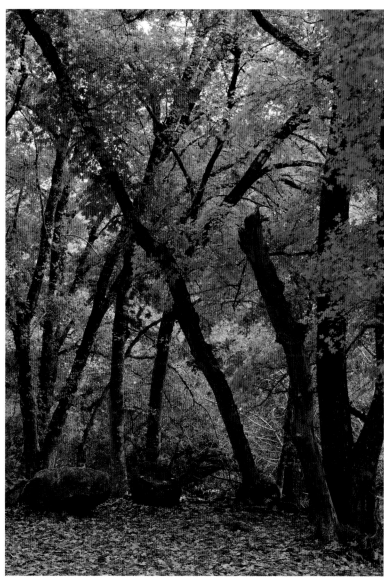

◄ A brilliant sunrise silhouettes a live
oak tree near Pecan Creek in McCulloch County.
▲ Bigtooth maples *(Acer grandidentatum)* in all their
autumn glory embellish Hale Hollow in
Lost Maples State Natural Area.

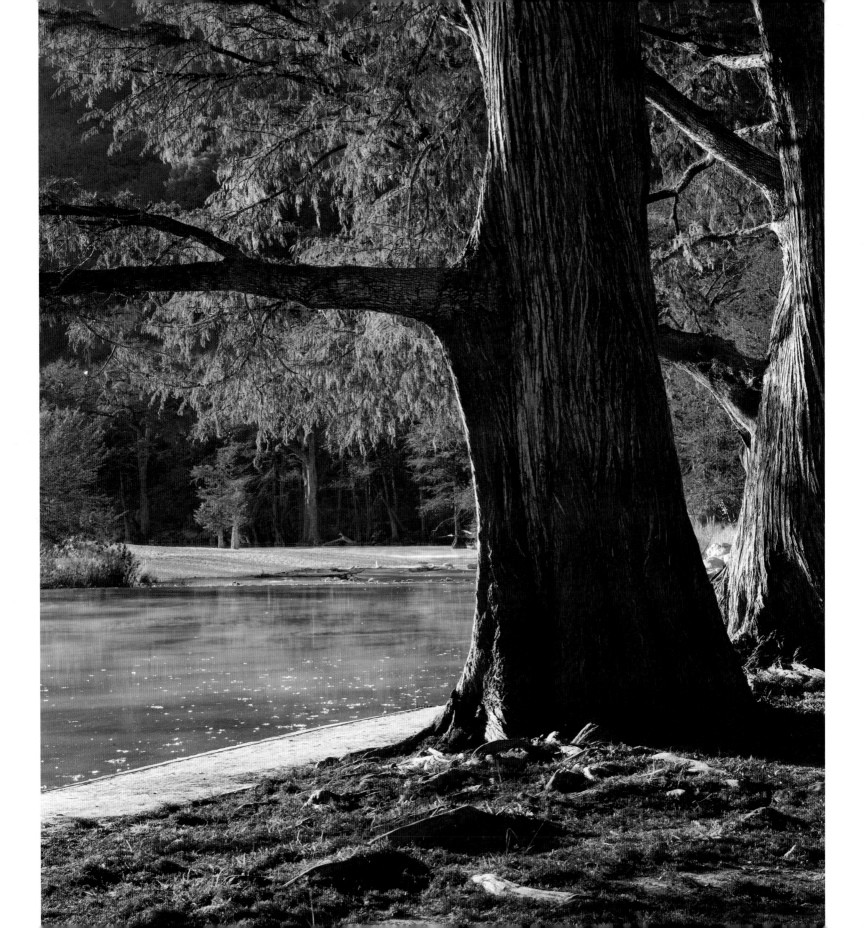

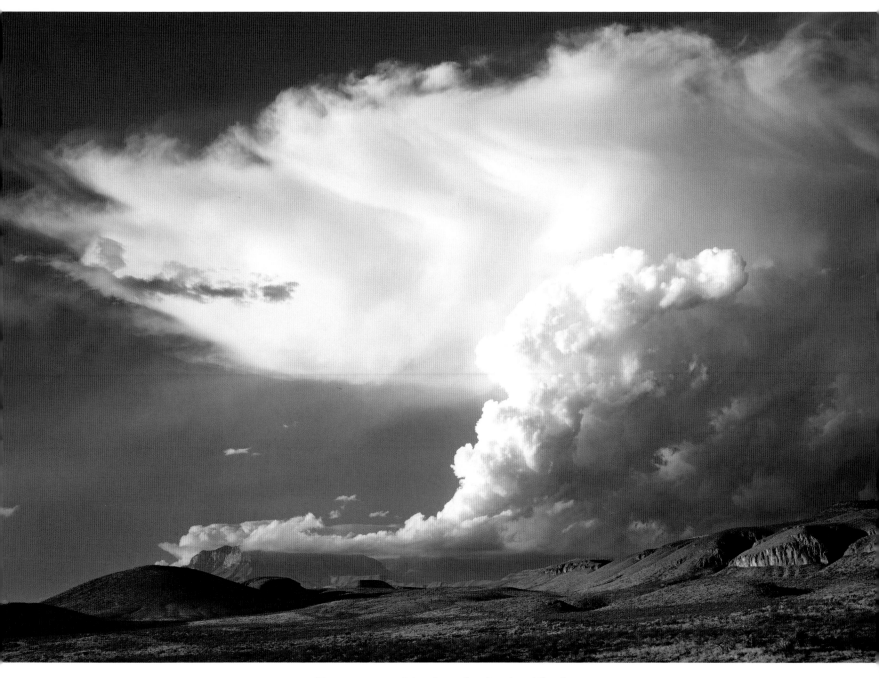

◄ Bald cypress trees *(Taxodium distichum)* in fall color
line the Frio River in the Hill Country's Garner State Park,
one of the most heavily visited Texas state parks.
▲ A thunderstorm over the Delaware and distant Guadalupe
Mountains sets off the deep blue sky. The Delaware Mountains stretch
thirty-eight miles southeast from just south of Guadalupe Pass.

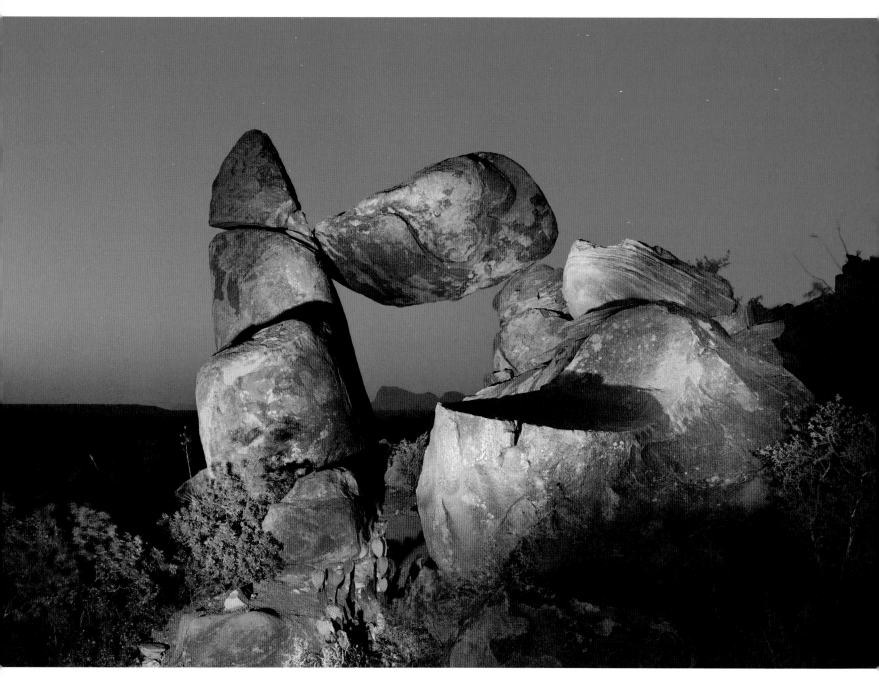

▲ A stone arch, created by a balanced rock,
rises in the Grapevine Hills of Big Bend National Park.
The Grapevine Hills are the eroded remnant of a mushroom-
shaped igneous intrusion. "Igneous" refers to the fact
that the rocks are a result of volcanic activity.

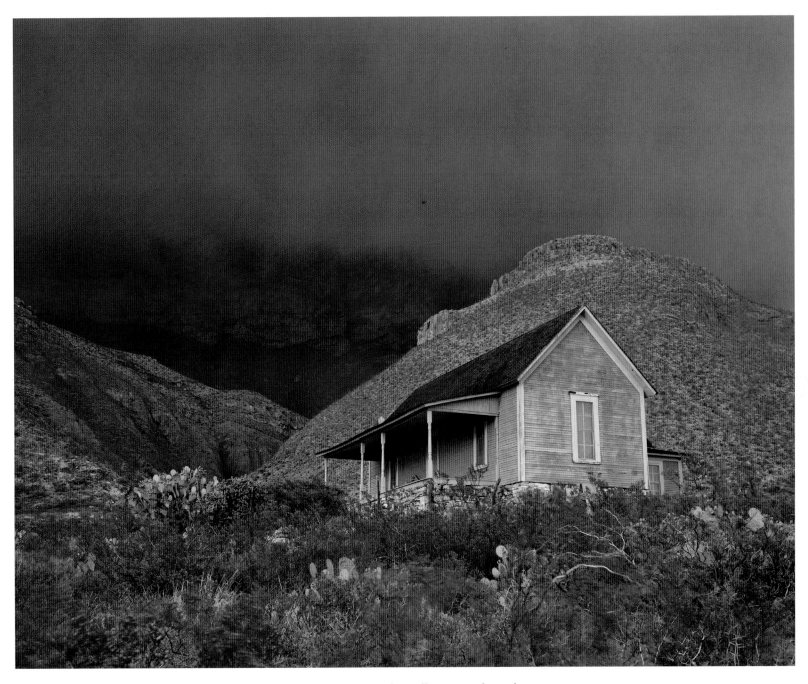

▲ The old house at the Williams Ranch nestles
beneath the towering western escarpment of the Guadalupe
Mountains. The house was built in about 1908 by Henry and Rena
Belcher in a very remote, dry area of the park. The ranch
was purchased by James Williams in about 1917
and managed by him until 1941.

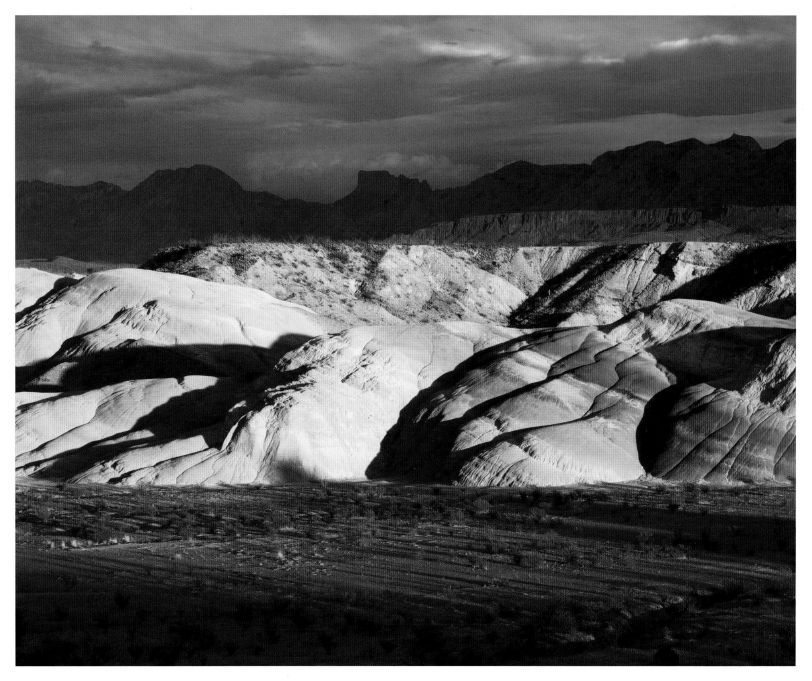

▲ The Chisos Mountains, the southernmost mountain
range in the nation, overlook badlands in Big Bend National Park.
▶ A torrey yucca *(Yucca torreyi)* blooms in the Bofecillos Mountains
above Colorado Canyon in Big Bend Ranch State Park.
▶▶ Bluebonnets *(Lupinus texensis)* line a dirt road in
Llano County in the Hill Country. Bluebonnets
were declared the Texas State Flower in 1901.

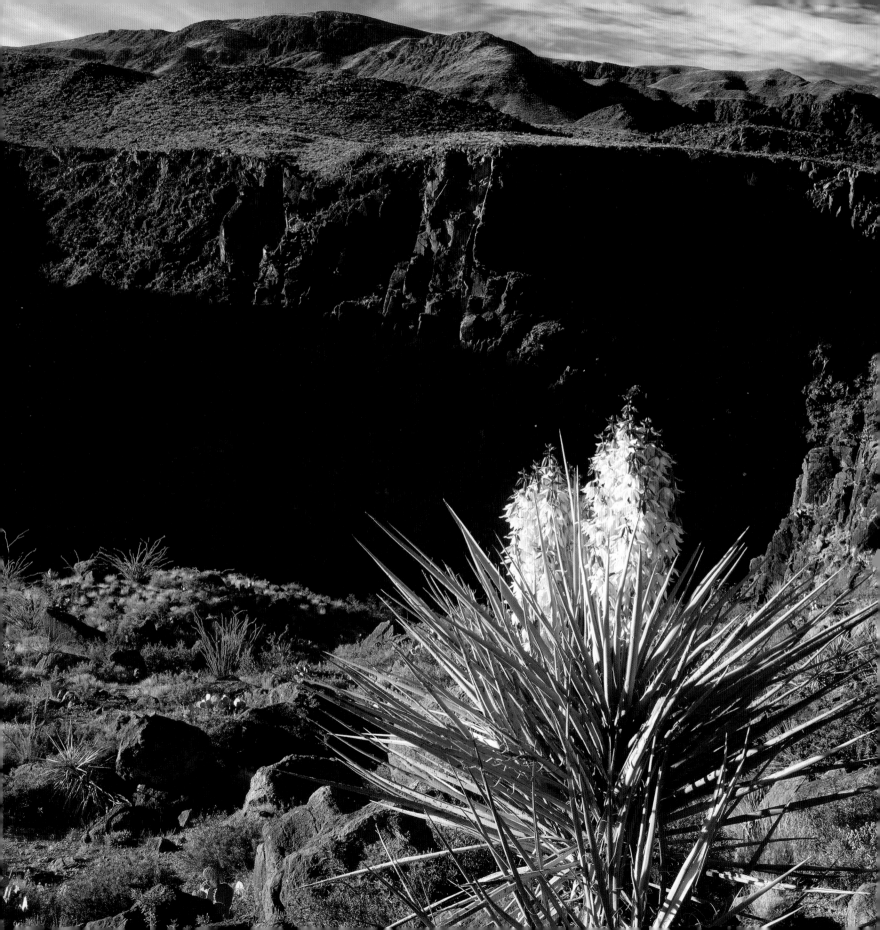

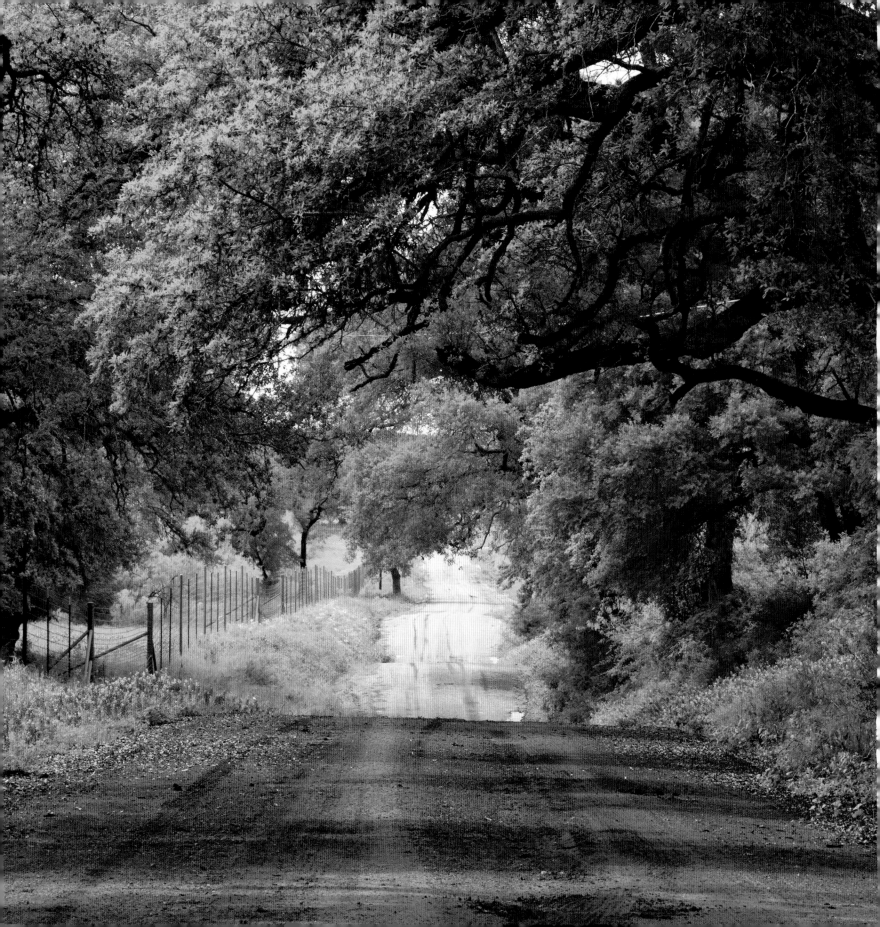